DISCARD

Wild Grace

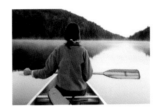

Wild Grace

Nature as a Spiritual Path

PHOTOGRAPHS AND WORDS BY

E RIC A LAN

W HITE C LOUD P RESS

Ashland, Oregon

For my mother,
Shirley Froyd,
Who has truly given everything.

All family and friends, my beautiful partner Jane and every other
living creature are also reflected in this book. You as reader complete it.
The gratitude I owe is endless.

Inquiries should be addressed to:

White Cloud Press, P.O. Box 3400, Ashland, Oregon 97520

Cover and interior design by David Ruppe, Impact Publications

First Printing: 2003
Printed in Indonesia

Library of Congress Cataloging-in-Publication Data
Alan, Eric.
 Wild grace : nature as a spiritual path : photographs and words / by Eric Alan.
 p. cm.
 ISBN 1-883991-53-6
 1. Nature — Religious aspects. 2. Spiritual life. I. Title.

 BL435.A43 2003
 291.2'4 — dc21

 2003043075

"If you love this planet

And you watch the spring come

And you watch the magnolias flower

And the wisteria come out

And you smell a rose

You will realize

That you're going to have to

Change the priorities

Of your life."

HELEN CALDICOTT

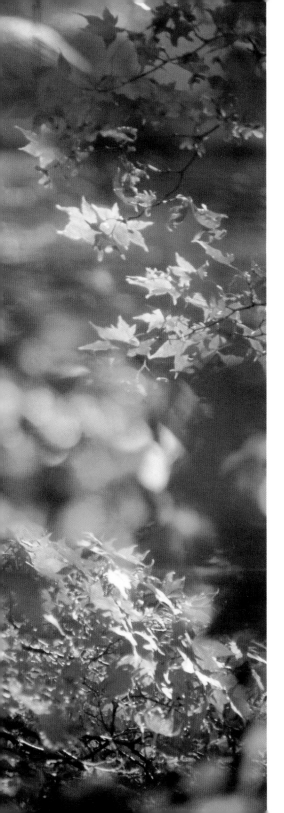

Elements

Sensing the Spirit

Living the Spirit

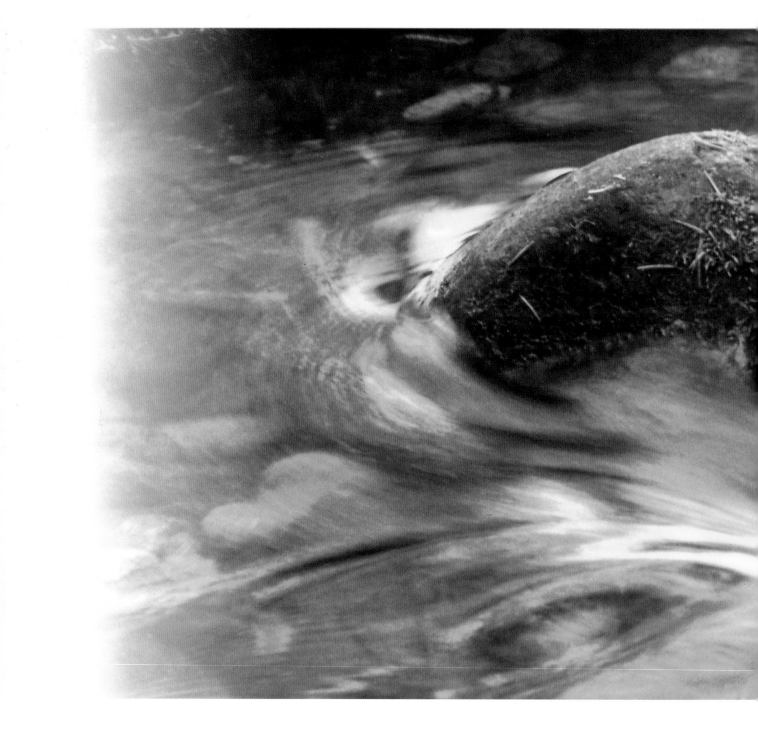

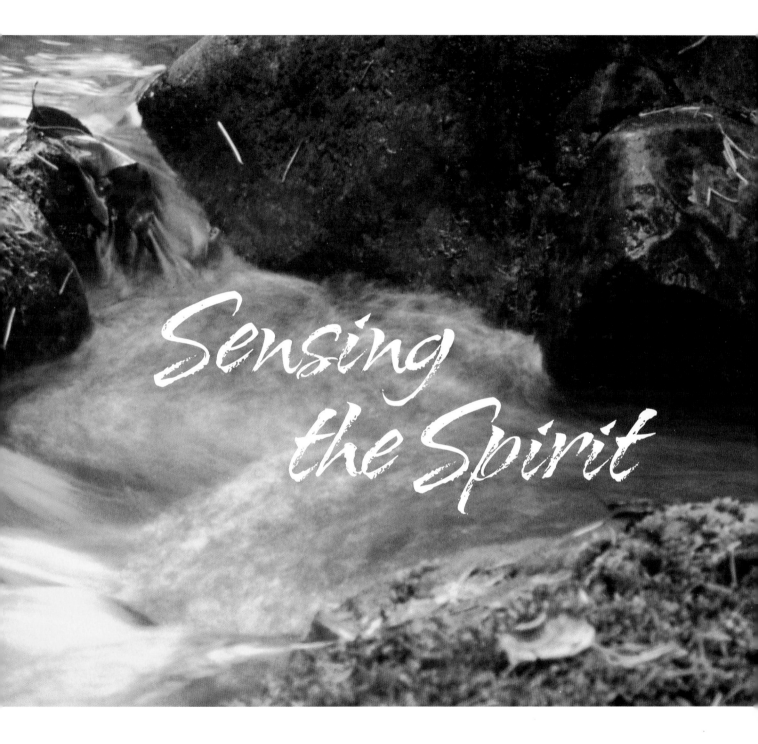

Sensing
the Spirit

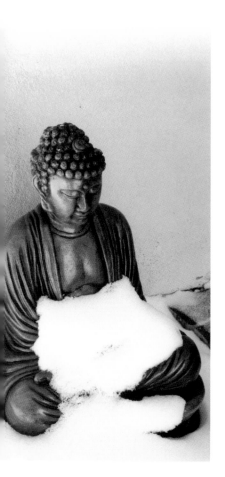

A Preface, A Prayer.

Inside, we are all born for the outside. We breathe the naked air, grow in the light of the raw sun. We spring from the soil as surely as the most tentative grass. Through the astonishing and mysterious grace of the natural ways, we have come to be creatures of awareness as well, capable of wonder, faith and deep feeling. We see the remarkable stretch of the place beyond and below us, and develop spiritual conceptions to make meaning of the vast patterns. For long ages, humanity has applied intuition and knowledge to create paths of spirit, to make sense of the larger universe, and to provide daily guidance for our individual footfalls.

Two thousand years after the founding of the west's dominant religion, spiritual seeking is a resurgent theme. Some who have grown up in a material rather than spiritual culture find themselves sensing an absence, and wishing to return to more calming ground. Others who have pursued traditional faiths find those belief systems now incomplete or inadequate. Many seek to integrate a heightened ecological consciousness with a spiritual one. All of us are challenged by the commingling and collision of different paths, as a global culture increases our exposure to vastly different notions. The result can be a crisis of spirit within the renewed awakening.

There is one spiritual path which contains all others, though; which conflicts with none. It is nature itself.

Nature is the path which fosters the life of all seekers. Nature neither requires nor precludes belief in deity. It includes both creation and evolution, without conflict. It demands no dogmatic rituals, and damns no disbelievers. Nature speaks only silently, offers no absolution, and has hard ways as well as sweet vistas. Yet within its silence and its graceful, tightly woven forms, it offers philosophical and practical answers. In the way that plants, animals and even the elements are and relate to each other, is an almost holographic, complete key to the balance we must find within ourselves and with each other.

We can follow nature's path through the tiny details of it present in our everyday lives—regardless of where we live and how damaged the natural order may be there. Nature offers a practical spirituality to be integrated into our daily lives as they are, rather than something we must radically alter our usual routines to include. It's a natural mindfulness that sees the whole of the answers to our questions and difficulties in the tiniest details of the living, natural earth.

What is this spirituality, and how can we apply it daily?

In the answer to this is both a beautiful celebration of the details of the natural world, and a meditation upon living in it. All that's required is our vision. This is a prayer for, and a glimpse of, that vision.

In the Cathedral.

At this sweet moment—whichever it is—you're in a cathedral. So am I. Always. Spires of trees may not embrace you as you read this; the soft prayers of stream whispers may be too far beyond walls for hearing. Still we can listen for them, seek them, remember them. We can recognize the clarity that comes from moments in pure wilderness, and learn to hold that clarity inside. We can use our connectedness to recognize that, despite the layers of concrete and pain we have layered over the land, nature still reaches us. In even the urban settings which often contain and confine us, there is nature to be found in every sight, every breath. That breath you're taking right now—which you could live only seconds if disconnected from— is in turn connected to the entire protective atmosphere that embraces the planet. So, too, the sip of water from your glass is connected to every ocean beyond the walls. Even the dust that now settles on your floor is a reminder of connection to nature, for it's a trace of the elemental ground of home. And in that nature is clear guidance to our questions. Calm answers to silent prayers.

We are always in the cathedral because we're an integral element of it. **Nature is something we are; not just something with which we relate.** In the beauty of following nature as a spiritual path comes an ability to recognize that: to feel nature's order in ourselves as well as in every surrounding.

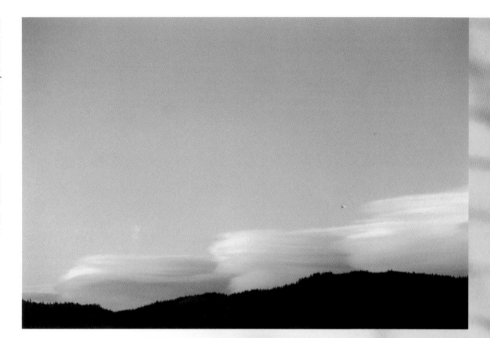

For me, it's easier to feel the whole earth as a divine sanctuary while at the base of a redwood whose patience has lasted a thousand years, than at the end of a traffic jam that seems as if it will last the same. It's easier to flow with the spirit of water at the bedside of a river whose commitment to flow never ceases or tires, than it is at a drinking fountain in the lobby of a sterile city hall.

Yet I've learned that **with practice, nature's vision and reverence can be brought forth via even the smallest, driest urban leaf.** It's entirely contained within the fewest lingering drops of dew on back alley windows.

In even the most barriered, forsaken, desperate building, there is still that breath of air to be drawn. And on each breath is a remembrance which is always available: *Breathing in, the wind is a part of me. Breathing out, I am a part of the wind.* I use it to bring awareness back to the truth of our constant presence in the cathedral. To our integral part in its being.

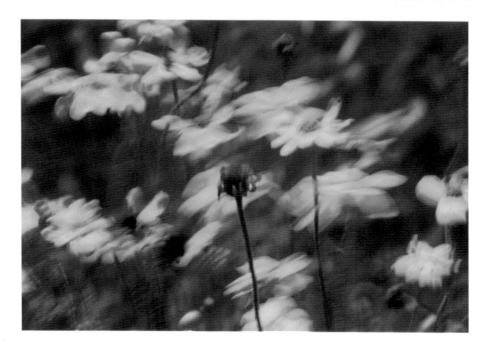

I find that connecting to nature's spiritual presence only while in wilderness is akin to only seeking connection with a higher spirit while in church. For those who choose it, that Sunday hour may be vital. It may be restorative and centrally grounding. But it's only one hour of the week. It's the thoughts and deeds of the other hours that put the faith into practice.

It's the ability to see high spirit and beauty everywhere that brings the faithful into the realization of their faith's healing powers. Along other paths, it's one definition of a saint: those who can see beauty in anyone, anywhere, and dare to look that beauty straight in the naked eye; to face the pain that's inevitably within the beauty. I think it no different in looking at nature. Our own darkest, most violent sides, are a part of nature too. We are always in the cathedral. We are stones in the cathedral's floor, ourselves.

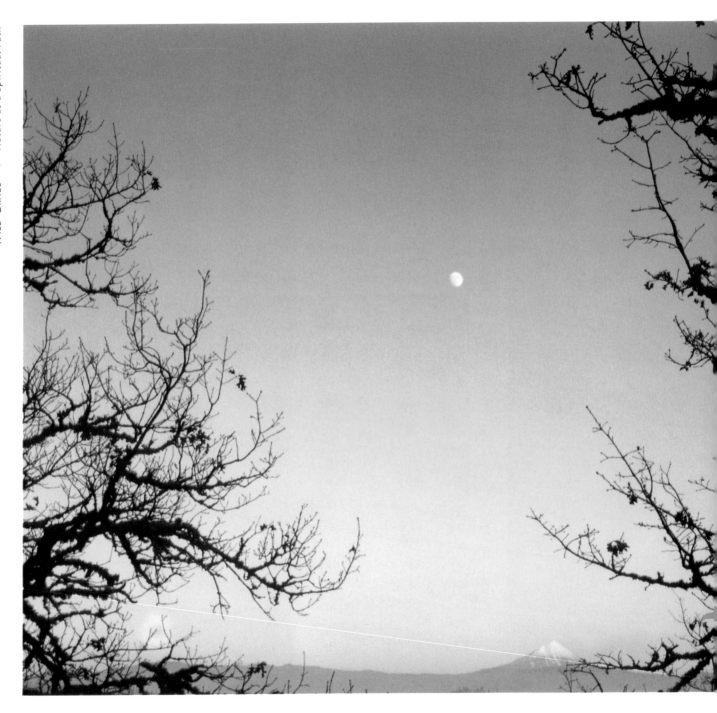

No Ceilings.

One deep reason for seeking a spiritual path is to gain a sense of perspective on the greater order and our place within it. There's limitless comfort in the result-ing feeling of belonging. A conscious way of being evolves; a reason emerges for every reverent step, and daily motions become made with certainty. There's also an end to a sense of isolation. Randomness recedes in the face of a clearer view.

So why the proliferation of ceilings which destroy that clearer view?

Our warm walls are welcoming and protective at times—they're a strong element of all that we label "home." Yet if we dwell too much inside them, we lose a much greater sense of home. We have lost the sky.

Our little constructions of plaster, wood and steel do exactly what they're designed to do: contain us. And sometimes that's nice. In winter, it's essential. Yet **when all of nature is the cathedral, being con-tained under ceilings is like sitting under a cardboard box in church.** All the spacious sights, sounds and other sensuous connec-tions are muffled, even suffocated. All the realizations that they bring are dulled as well. There's a sadness in ceilings that the vigilant can't deny.

Light, illumination, is what we often say we're seeking when staring at questions and challenges. Yet, out from under those restrictive ceilings, it's

the dark night sky which often allows the best soothing return of perspective. In that sky and beyond it, almost all of the cathedral rests.

It extends beyond the borders of perception, even aided with the most miraculous telescopes. But we need no technological aid to regain perspective. We need no electricity. In fact, the perspective of the stars is best gathered without it. With no electric lights in the vicinity, **a simple upward glance returns us to a clear view of our almost invisible celestial place.**

The purity of a wilderness sky, though, is rare for any of us to be able to reach with regularity. The wilderness has been driven out of our homes, and with it has gone the wild grace it placed in our hearts alongside the hard danger. We have to reach for what slivers of sky are available to us, and learn to be grateful that with a practiced eye, an open window and one star will do, for clear vision and remembrance.

Each star makes its steady, persistent statement of scale and presence regardless of the attention of any viewers. That kind of persistence and steadiness has been one of the greatest lessons for me, has provided one of the best role models, in pursuing my path of expression. The stars inspire me to continue being my true self as best as I can, regardless of my distance from the crowd, or my invisibility within it. The stars teach me to continue speaking my quiet truth even if there seem to be no listeners. Words, like starlight, can take far longer than their source's life to reach their destination.

There are those who find our infinitesimal size frightening—especially compared to the distance between even the most neighborly stars. Some cannot look at the stars for fear of disappearing alongside. But our smallness doesn't make us insignificant. In fact the vast black stretches where no life dwells make this planet's exception that much more sacred; our own life within its weave is that much more precious.

In our own near disappearance is also the largest personal comfort. There's infinite room to breathe deeply, mindfully. In that space of breathing under the stars, your own airy rhythm can easily contain whatever ails you.

Explore tonight: take the largest problem you currently have with you, to whatever sliver of sky you have available. One window and one star will

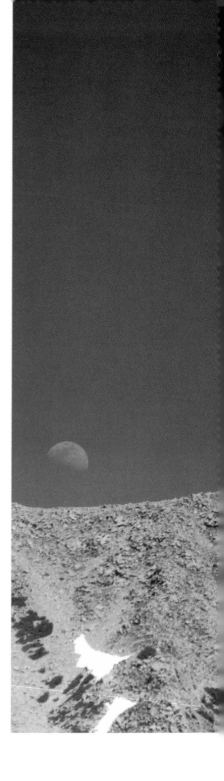

do if they have to. Focus on that star and breathe, and remember patience; for remember how long the light from that star has taken to reach you. Give it respect, and give it attention; for that particular starlight, after its journey of ages, will have traveled for naught if you ignore it. It will never return. Its tone is as pure as that of a bell—harmonize with it. Sing to it and breathe. And again compare yourself and that problem to the distance. If you can still remember that problem by now.

You are far larger than your problem; and you too have noticed how you vanish against that star. No matter if the problem is one of love, family, friendship, career, health, trauma, disconnection from spirit . . . It, even more than you, fades into nothing in face of the stars. **Even our planetary tug-of-wars and environmental screams cannot cross the smallest black gulf to trouble our closest neighbors.** Our problems are tiny, remote, and yet we are centered exactly on the point of the only living sphere for a great stretch of space. A freedom from ceilings, and we immediately remember.

No Floors.

On occasion, just for a moment, I catch a glimpse of the truth of the universe. It's not an intellectual grasping of some serious large Truth; it's not a mind understanding at all. It's just a fleeting, wordless awareness in the heart: it's a pure sensation of grasping the absolute, wondrous, unknowable enormity of all that exists beyond our tiny sphere of perception. It instills an awe that washes all tension and thought from my soul. All voices are silenced inside. Only the breath remains.

That silence only lasts for an instant, before the tides of chattering verbiage veil my awareness once more. But those instants are enough to instill lasting memory, and memory of that truth helps bring the awareness forward again.

The silence of the awe was most reachable at first for me through the grace of the night sky. It was only after enough brief openings to the truth of the endless natural wonder that I began to sense that the same cleansing awe, the purifying silence and refreshment of the soul, could be found as easily through the miracle of the minuscule as well as the extensive.

The endlessness that pervades the sky also informs the distance that separates us from—and connects us to— the unknowably small.

At each level between our own existence and that of the smallest parti- cle, an entirely distinct world exists, radically different but not separate from our own.

It was glass that began to show this to me most clearly. More clearly than if the glass was not there at all. A certain kind of glass; a focused glass through which focused vision developed. The lenses of my camera allowed me to enter the earth at a level other than my own. That level wordlessly showed me what it was to feel the truth of small color.

How does the bold red of a single blooming petal feel to the senses, when it's large enough to fill the whole vision? How does it feel to be the insect absorbed in the world of crawling across that petal?

I learned I could cross huge vistas by disappearing into the tiny. Suddenly I knew that there are no floors, ultimately, any more than there are ceilings. There is no ground so solid as to be impermeable to vision. This changed everything.

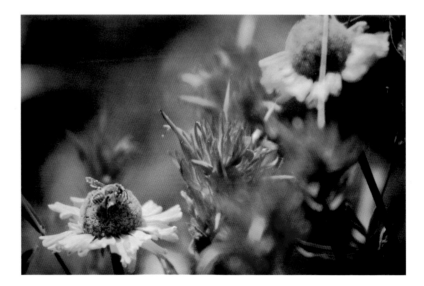

In the miniature worlds at my feet, now, with or without lenses, I can see realities as removed from our own as that of unknown creatures orbiting distant stars. The differing lives and realities are at the end of our skin on all sides, within a place small enough to require great sensitivity to see, smell and taste. Even more than that: the endless levels are inside of us too—it's obvious and yet continually forgotten. Inside, lives of blood cells and bacteria and other life know our bodies as the universe, as surely as we in turn only know the belly of a larger universe that we cannot conceive beyond. It too, may be only one body of unknowable billions.

Peering into the endlessness of small details—countless levels of which exist beyond even the reach of the best assistive lens—restores perspective as much as another comforting disappearance under the stars. **Just sitting, closely watching the tiny details at your feet, is a practice that can bring release as well as perspective.** It is indeed a practice, just as yoga and meditation are practices; and in fact yoga and meditation have much to do with the perspective of the details and the stars. Every yoga pose asks for a counterpose for balance: perspective asks the same. A view of the enormous sky asks for a view of a single inch of soil at our feet.

Only with both is there completeness, and only with bringing a meditative, still eye to both is there depth.

While disappearance into a field of untouchable stars returns a comforting smallness, and gives a

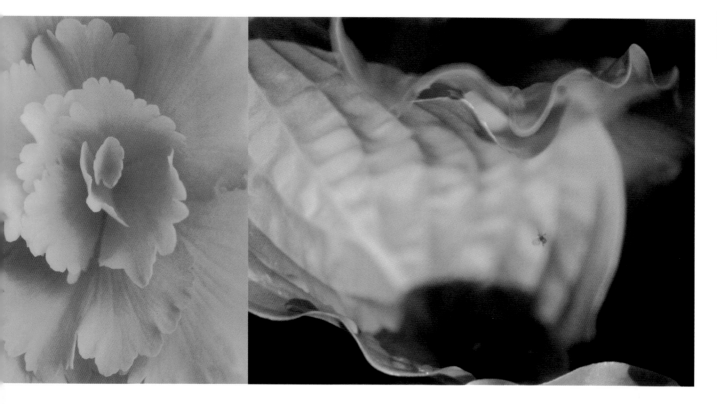

soft dark blanket to be deeply enfolded in, disappearance into the tiny returns an equally valid sense of our great effect on the small elements of the world—elements which provide the basis of our lives. **Every footstep can respect or crush a thousand tiny lives**; each breath inhales and expels more life than we can measure.

The spiritual path which preaches avoidance of all harm to any individual creature, while noble in its intention and result, is not what nature teaches by example. Instead it teaches the necessary loss of individuals in favor of the greater balance. In its insistence on struggle, nature teaches the central role of pain as well as peace in the higher harmony. It's a hard spirituality, in that sense. It offers no promise of a sweet by-and-by; not even a certainty of a soft present—although it does not preclude either.

What nature offers instead is a staggering depth of real beauty in each present moment. It offers an unspoken proof of the remarkable possibilities of higher harmony between millions of species—of collaboration within the struggle to produce an astonishing weave of graceful life—all with no effort more than instinct required. It offers the knowledge to the observant that **beauty exists on so many levels that we can only begin to imagine how beautiful our own world is**, let alone the totality of the exquisite universe it's nestled in, and whatever may lie beyond.

In recognizing our power over the tiny lives we often don't even perceive, nature grants us an opportunity to develop respect and consideration in every footstep. It also offers an awareness of our individual strength. Through our relation to the small details, we can come to know that there is great cause and effect in every motion. To know that despite the enormity of the universe, we have an enormity of our own. This appears true for each creature within the great chain of sizes that we can perceive.

We are therefore, in that regard, exactly equal to the creatures and living systems above and below us in that chain of size. So do we not have equal responsibility to be humble before that order? To participate in it and care for it as it needs? And since instinct provides all the care necessary for the balanced evolution, is it not true that every step away from instinct and into intellect has led us away from balance and into "civilization"? True civilization and progress would mean an evolution within nature's balanced order, and not one which transiently arranges human comfort at the expense of all else.

To return to the beauty of floorless details can return a soul in an instant to a more balanced place of the heart. I find that a view of an insect on a leaf, for instance—seen without the temptation to analyze, classify,

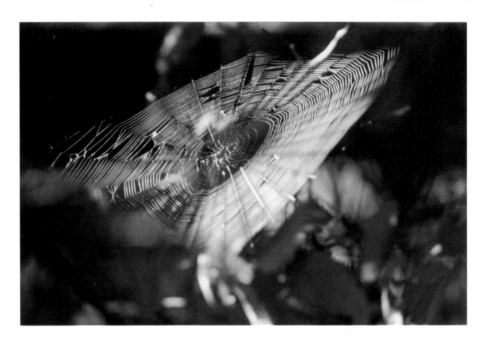

capture or otherwise disturb—can return me to that inner balanced view without effort or words. That's a remarkable discovery: that **despite the key elements of struggle within nature's path, it's an absence of struggle that returns the heart to balance.**

That place of balance is a place of pure sensation. A place of simultaneously knowing our enormity, our tininess, our equality, our strength and vulnerability. It's a calming silence we were born to know.

Flowing.

We are liquid. It's tempting to think of ourselves as more of a solid: the images abound, after all, which push us towards that state as an ideal. "Nerves of steel," "solid as a rock," "iron man" and the like. But that is not who we are, even though we may draw as much strength from stones as from water.

Stones do have great lessons to give, and I have learned much from their silent ways. Still, it's not granite and gravel flowing through our veins, and to have a heart of stone is a cliché of insult, not ideal. No, we are liquid, as much as a glass of water is, as malleable and also as fragile—as prone to apparent disappearance. **We flow through the world, at our best. At our highest we are closest to being a river.**

Water has taught me more than stones; more than cities; more than paperbound volumes ever could. It has taught me ways of seeing our collective spirit and our individual selves which are of profound practical value. It has also given me hypnotic reflections of the world and its colors which are endlessly kinetic, perfectly real and abstract at the same moment. Water

is calming in its constant rushing noises, as well. It's the only soothing hurry I know.

The image of the collective spirit as a vast ocean has been a recurring image for founders and followers of many spiritual paths—all of whom found it from the ultimate source: the nature from which each of those paths rose. **All spiritual paths are rooted in the same water and the same creatures that first crawled onto shore from it.** No surprise, that many should reach back to the source for vision.

It takes no belief in deity to see that same vision: only an observation of water and its nature. Water doesn't vanish from this planet: it merely changes form from salt water to rain cloud to river to steam, fog to sweat to dew, lake to ice cube to misty breath. It's in constant change, dividing, separating, merging, traveling, vanishing and reappearing in the limited view of the naked eye. Yet its underlying constancy is timeless.

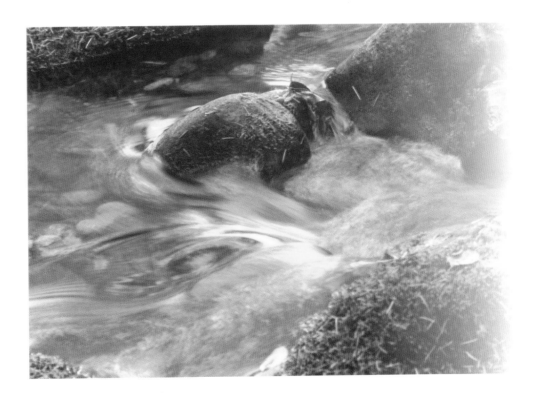

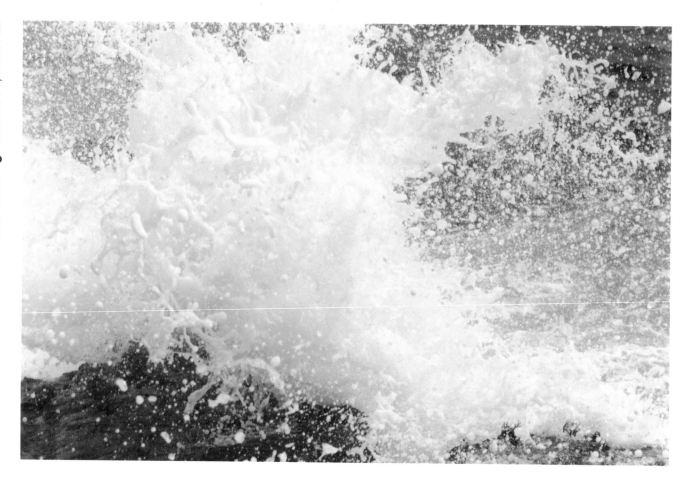

The associated metaphor which crosses boundaries of faith compares our lives to waves on that great ocean of life and spirit: each life rises and falls and returns to the mother ocean without the water vanishing.

Seeing this way, I grasp the view which recognizes neither birth nor death; instead recognizing spiritual continuance in other forms—other waves rising after the fall of the previous.

That vision is most easily felt at the edge of the ocean, on the shore of the greatest waters we've been given to borrow as metaphors. There, no far edge is visible, and at the near edge the waves keep their ceaseless rhythm without ever a whisper of exhaustion.

Not all of us have access to those oceans, though, across vast land-locked distances. Gaining water's perspective is like gaining the perspective of the stars: any connected resemblance will have to do. We all have water in our lives—if not, we're quickly banished from the living, and in our own way return our moisture to the world. At every drinking fountain, puddle, drop of dew, river, glass or faucet, that connection to the one great ocean and its comforting timelessness is available.

It's small waters—rivers and lakes especially, but even urban trickles and puddles—from which I've learned the most about how to be in the

world. It's there I've learned how to follow nature even in places where it seems distant. So many times I've paused, to admire the way water lives.

Water always finds a way, with its delicate balance of persistence and flow. Its path and goal are always clear and simple—to move downhill towards the sea—but its moment-to-moment journey shifts instantly and endlessly, without heartache, according to the landscape with which it's presented. **Water always follows a course towards a clear, direct goal without needing to resort to straight lines.** The best path, it knows, is not the shortest or simplest; but the one along which the flow is most natural. It's in the curves and switchback changes—in silent pools balanced with shouting rapids—in which its beauty lies, as well as its success in fulfilling its purpose.

If a rock impedes its flow, water simply pours around it. If going around is first impossible, it builds up until it spills over or moves the rock. If cold

becomes extreme, it simply freezes and waits for a thaw before resuming its motion, content with the earth's schedule of seasons. If heat becomes too intense, it rises without resistance into the air, particle by particle, absorbing itself without demand into the atmosphere until it comes down in some other form, some other more hospitable place.

As long as it can gather enough for visibility, too, **water's nature is to reflect the beauty of the world around it.** The reflections it creates aren't bent on exactness, that delusion of "accuracy"; instead, water uses whatever colors are given to return something new and beautiful which is uniquely its own, and also directly of the world around it.

How I wish we could each find such creative grace! How I wish we could all move so easily! When I'm confronted with obstacles in my life, internal or external, I ask myself one question:

What would water do? Would it go around, would it build to push through, wait for a thaw, accept the heat and rise to come down in some other place? I draw upon water's stressless, adaptable persistence. *What would water do?* I take a sip from the nearest drinking fountain, glass or faucet to draw that water and its ways deeper inside me. *What would water do?* In the answer to that question is inevitably the answer to what direction I should take, given the obstacle—and also the beauty I should try to reflect. *What would water do?* We should know. We are liquid.

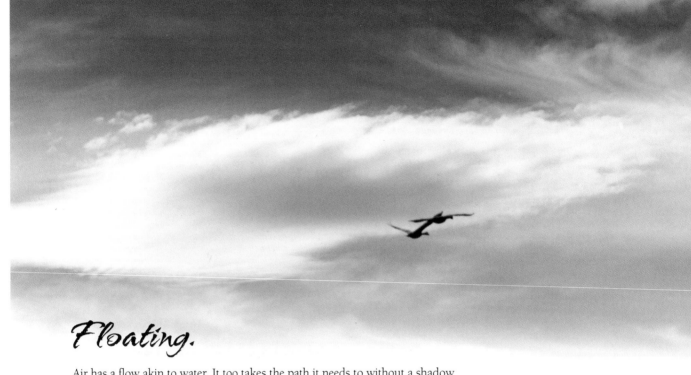

Floating.

Air has a flow akin to water. It too takes the path it needs to without a shadow of resistance. No border exists between air and water; air carries moisture like a mother carries child, releasing it when it's grown enough to be free.

We're no more separate from the air than water is. Yes, air is distinctly around us; you can trace the border of your skin with a finger. But we each breathe in, and then that air is inside us. What the breath keeps, becomes us.

We are engulfed in air, as well. An aura of it is an essential if invisible part of our being. Without that aura we return to the earth in a matter of brief moments. Air is godlike: it's a greater power that controls our living destiny.

Breath is our center, then, our very basis. Given its instinctive ease, it's simple to lose awareness of its centrality, its connection to high spirit. But in breathing is our key to calm, to closeness to others, to peace, and other purity. Stillness of breath brings stillness of mind—that's a quiet, common, ancient truth. You can feel it in every mindful step: **Breathing in, the wind is a part of me. Breathing out, I am a part of the wind.**

Silent Support.

The earth speaks in quiet affirmations. All that we call language, with its strings of words and human meanings, is but a narrow part of its living communication to us.

The other noises of creatures' calls, often opaque in meaning across a distance of species, add to our own cries to broaden language's scope. The vegetative sounds of leaves and branches in the wind, and all other living sounds that speak without a mouth, talk to us as well.

From sweet tones to solemn, soothing to raging, there is all manner of earthly speech. Silence speaks with the most powerful voice of all, at times: sometimes with no more message than its own healing power; other times by allowing the inner voice its own chance to speak, at last. All is communication to be listened to; all of it has meaning we can interpret or add to.

Naturally, the earth speaks to us without using words—
via wind and weather and strange facets of beauty.

I find that as a reward for creating harmony, for compassionate steps
taken, for pure hard choices I've made that keep me along the path of the
heart, that quiet affirmations offer themselves. A coincidence of birds at a
moment of my own song; a falling star's timing attuned to a good decision—
it's these kind of messages I hear as affirmations. I find them in urban places,
too; in affirmations that might not at first seem a part of nature. They're in
money found at streetside; in music that falls in rhythm to the drive. They're
remarkable for the continual resonance they give to a kind act done, a good
decision firmly made. They're also remarkable for their absence when
disharmony is chosen, when the path to my purpose is betrayed, or when
I'm removed from returning beauty to the world which has given so much
to me.

At this book's genesis was such a moment. The beginning of autumn was arriving with its usual clamor of working demands. I had retreated for a Saturday afternoon with the trees and the creek, the warm but waning sunshine that would soon gain a winter chill and vanish into gray. I came to ponder this book's concept. The agony of indecision arose in me, though, upon arrival at treeside. Should I leave instead, to attend to my list of a thousand things? Were errands a better use of my time? I could busy my hands and ignore the silence and its dangerous release of my own inner voice. If I left, I could withdraw from the pure, silent world, and by missing the beauty, avoid all the danger that beauty brings. Or I could stay within the pain of silence and beauty, and pass through that pain to where only the afternoon's beauty remained, and dare to believe that this book was worth beginning. I could stay and begin to face the reflection of the world upon these pages. I laid back on the grass for a minute and stared at the sycamore canopy far above. I breathed with focus, to take my heart back to center, my mind away from words. *Breathing in, the wind is a part of me . . .* In, pause, out, pause, in, pause, out. *. . . Breathing out, I am a part of the wind.* Pauses as important as breathing, like silence as important as speaking.

When harmony settled to the core, the silent answer came, distilled from between thoughts. I would stay and dare the words, risk the sunshine. I would take the harder, more beautiful path.

Decision made, tension released, I opened my eyes to see a sycamore leaf release exactly then from the top of the grove canopy. Unlike most of the leaves using the wind as a path to the ground, it did not flutter and tumble. Leading with its stem, it kept the same side down as it traced a perfect, centered spiral. I watched it glide with focused calm direction as it came, closer . . . closer . . . to touch at the very spot I instinctively knew it would. I lay motionless and willingly remained defenseless as the centered spiral ended with the leaf stem exactly hitting my heart.

The earth had spoken its affirmation. I was in the right place, along the path the earth had invited me to discover. I was at ease, then, and the words began to flow into the place where you now read them. As I type them in, that leaf is still beside me, in a place of honor on my desk.

The earth's affirmations are small, quiet, easy to miss or deny. They almost never have the volume of a door slam, a pain cry, or an aggressively barked order. They aren't orders, after all. They're thank yous for a choice of beauty, and it often takes a vision of beauty, developed as a skill, to notice them. But I've learned through constant experience that they subtly exist, and that if they don't show from time to time, despite my best awareness, I'm walking off my path. I'm not following nature.

The faith that these quiet affirmations require is something I restore by watching birds. Birds strike me as very faithful, spiritual creatures, for in

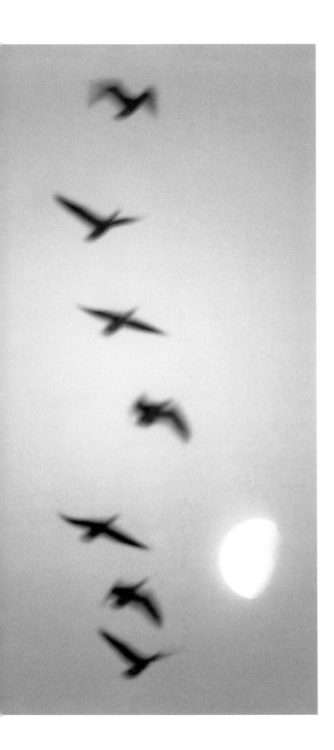

every leap from a branch into the wind, they place the absolute trust of their lives into the invisible.

Were the air not there to carry their wings, they would only crash in their delicacy onto stones far below. They may never see the air, or think of it with other than instinct, but they trust in it with absolute-ness. We must trust in the world with that same absoluteness. **We too must jump off branches when our soul knows we are ready for the air.** We must give ourselves over to the world and its quiet affirmations. We must affirm the earth, in return.

The Faith of Stones.

As relatives go, stones first appear to be a cousin more distant than near.
Our kinship is across borders of great difference, it seems, from our warm
liquid core to their cooled hard one. Their time on this earth is lengthy and
without breath or sight, while our bright brief lives flash past them. Many
would say stones have no life at all, although my view differs, since the
earth in totality carries living spirit, and stones are an integral part of that
earth. Stones' part in the cathedral's spirit is just silent and very different
from our own.

Difference is not truly distance. On the raw earth we walk and rest
upon stones, quite closely. And if we look at the whole earth as one stone,
our close kinship becomes more apparent still. The earth, like each of us,
has a warm liquid core, invisible and essential. The cooled surface stones are
akin to our skin; to the flakes our skin releases to mingle with the universe.
This great earthly stone has a pulse in its veins.

There is much I've learned from stones' quiet ways. In our cities we
mold them or create materials which imitate their strengths, turning their

hard elements into streets and structures. From a single grain of sand to overpowering sacred mountains, stones form a continuum that is always close to us, always vital, always the basis for the support of our moving feet.

Stones don't hide from the weather—one lesson I draw from them. They need less protection for survival than we do, of course; the effects of ten thousand raw winters only begin to shape them.

Still, I see an admirable acceptance of the weather, as devoid of explicit consciousness as it may be. Stones don't resist it. They allow it without complaint to slowly shape what they are. The result is that it smoothes their jagged edges, polishes them. **Hard weather gives stones a more refined beauty; the same process informs our softer, briefer lives.**

We are shaped by the weather too, the heat and storms of outside and within. It's in accepting direct closeness with it that our experience is most felt; our beauty most directly shaped.

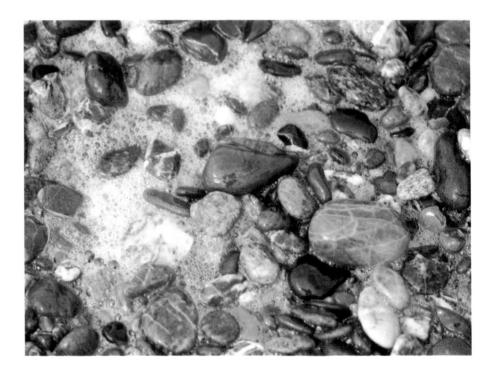

If we barrier ourselves against the physical and emotional rains, we remain rough, untested, unshaped.

We have limits of tolerance that stones do not, of course. No senseless taunting of hurricanes will serve us. But I find that when weather is testing me, I can draw great strength and calm from a small smooth stone, turned in the palm. Its acceptance, its willingness to become beautiful by long exposure to experience, and its steady patience all are key strengths I can draw from.

Indeed, there is nothing more patient than a stone. A hundred million year existence gives a different perspective on time. So when I feel myself straining against the minutes, pushing uselessly against time's own strolling rhythms, nothing restores me better than sitting on a large rock and breathing in its slow character. I can take a bit of that character home. It doesn't need to be a rock in deep wilderness. Any rock will do. And though a large rock is better for sitting, even a small rock for holding is enough to connect to the strength and faith of stones. Stones, which never leave you, which never ask you to be what you are not, which never complain about the difficulties given them. Stones can wait. And so can we, more often than we know.

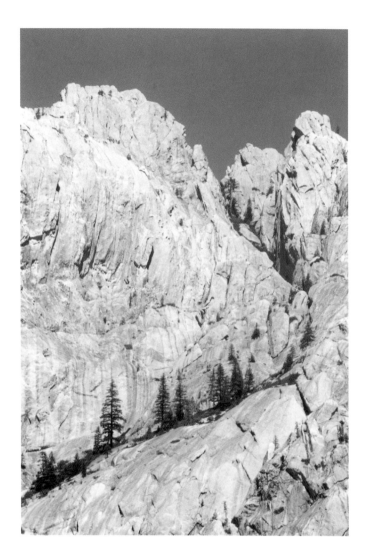

Larger stones have served as great guardians, over the years. **Boulders and cliffs look down in watchful ways, providing constancy as well as protection.** The cliff-dwelling people of the earlier earth knew a deeper sense of this protection—born out of need—and drew their very existence from the faith and shelter of stones. Outcroppings and rock walls provided defense, also; a place to retreat to and make a stand from when the external threats were beyond tolerance.

Large stones have also provided internal practical guidance: their steadiness is a faith to steer by. It's a constant presence that can keep us knowing better who and where we are. It can help us provide the same constant strength for each other.

Stones have centered some of the greatest constructed prayers of the human ages, as well. From Stonehenge to the Mayan temples and European cathedrals, prayers and messages to the gods have been formed from rock. It would be odd to view rock as spiritless when it has so often been chosen to center great monuments of worship.

The most exceptional natural stone formations remain sacred even in many modern secular lives. In America, the system of national parks and monuments recognizes the preciousness of great formations, although it divides the continent into protected land and other land inferred permissible to ruin. The great formations can inspire the same breathless wonder that

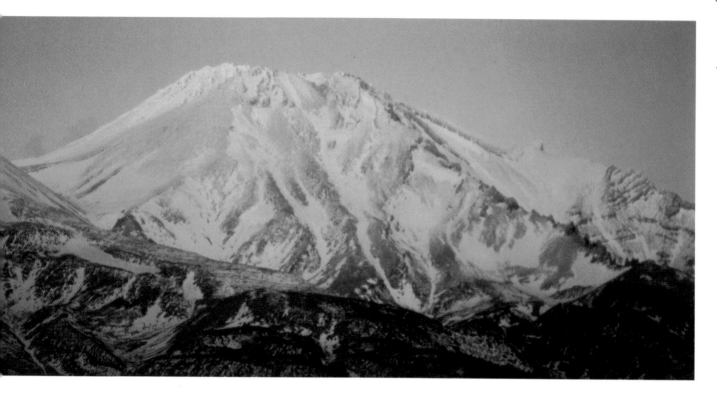

the great cathedrals do, even in those who do not choose them (or any-
where) as a conscious place of worship. They are complete cathedrals, whole
in themselves, and also mere elements of the larger cathedral in which we
always walk.

 Nothing is more sacred than a mountain. No land is
closer to the heavens beyond us. Many native peoples knew this, long before
others came along to see mountains (and people) as merely something to be
conquered. The mountains, though, show little concern about our con-
querors' games. Their highest peaks are protected by muscular weather and
hard conditions. And they will outlast us, after all. They have the patience
and the faith of stones.

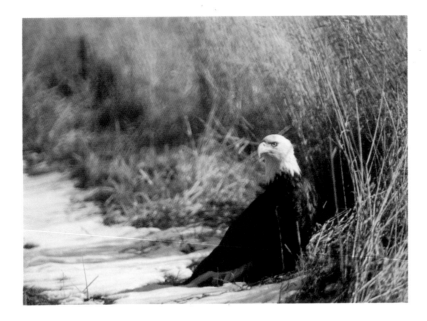

Life Giving Life.

As wise as the earth is, **the myth of nature's boundless benevolence can be shattered in three words:** *things eat you.*

The natural order does not offer the comfort of a pacifistic heaven. The wilderness struggle, for the individual, is more a raw state of war than peace, no matter how beautiful the surroundings may be. Constant vigilance is required, for daily dangers are real. "Natural enemy" is not an empty or contradictory phrase. Vulnerability to becoming lunch, instead of merely going out for it, is an intrinsic fact of nature.

From the individual's perspective, this system can seem cruel, as perilous and full of pain as it is. Blending with it—let alone revering it—is a difficult concept. Harmony with enemies? Oneness with creatures of other species whose purest instinct is to hunt you down and eat you? Unnatural, from the perspective of the individual's gain. As out of step with the natural order as killing no creature—and as impossible, especially if you recognize plants as alive, and not just animals. You have to eat *something.*

Nature does not choose the perspective of the individual, though. Its focus is more selfless and total. **Nature selects for the health and life of the overall spirit, regardless of individual pain involved.** It's very giving in this regard, offering life to sustain life. To nature, individual death is of no consequence, as long as that death feeds other life and sustains the balance. In the larger perspective of the collective spirit, it is therefore not death at all. It's merely a transference, a continuance.

It's through this transference that the overall living weave has thrived since the beginning. Nature thus teaches the selfless perspective of under-standing the role of life's passing within life's flourishing—a perspective which offers great comfort. It isn't personal eternal heaven, perhaps; but it

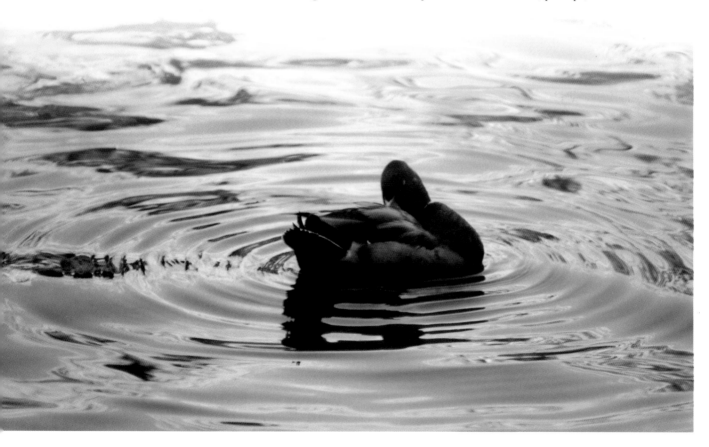

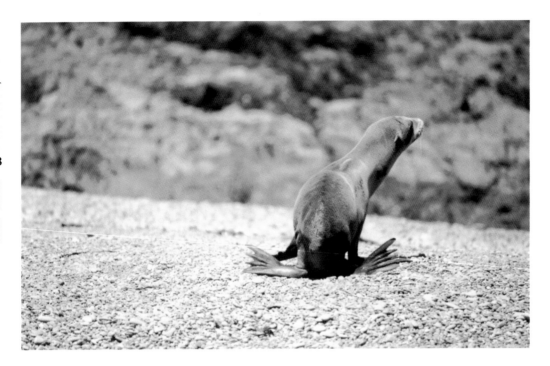

does show each of our passings as a gift to those who follow us. We leave space and energy for there to be other flourishing awareness when we go.

Not that nature teaches us to roll over and offer ourselves needlessly to any enemies in passing. The striving for individual life is also part of the balanced order. The value of preserving our own spirit's place within the weave is instinctive. It's true in all beings of all species. And it's through valuing our own lives that we learn to value others, including the greater collective other.

Also, on the path of survival, the struggle keeps us fit. **No sedentary, lazy, pot bellied creatures grow old in the wild.** They give room for the new soon enough.

What nature does not do, in this balance of striving, is to take life needlessly. Some may perish in the randomness of weather and earth shifts, perhaps; but when one life absorbs another it is indeed a transference, not a destruction. The difficulty with human conflict, then, from this perspective, is not that we take lives—even of our own species—but that randomness

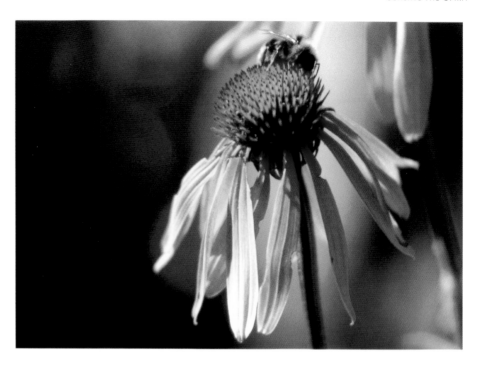

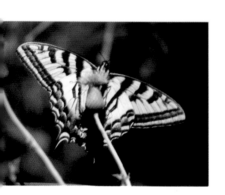

and senselessness have crept in to poison the instinct. We take life in a way which does not feed life: our wars and our street fights merely destroy without transfer. It would not feed anyone, for me to kill you.

What we call disease may be another matter, however. Disease which takes life is life also—bacterial or viral life—asking for transference of spirit too, in its own microscopic ways. And disease often strikes overabundant species as a means of returning greater balance. This is where believing in nature as a spiritual path becomes painful—for if believing in nature means believing in the overall balance, and if believing in the overall balance means a need for reduction of one's own species... the conflict with the self-preservation instinct becomes severe.

Within the darkness these natural shadows cast, though, there is the light of greater health to be seen. **There is certainty that nature will take action to right its balance, because it always has, on this sphere.**

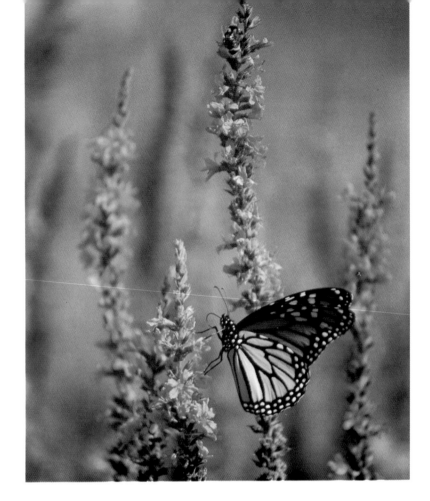

There is also, in life giving life, a model for our own daily ways of being. I've begun to see my own life as a long process of transference, especially as the relative independence of adulthood has set in. Do my daily actions, in what I eat, write, speak, touch, do, feed the life which is beside and beyond me? Does it set up the continuance of my own positive spirit in a time beyond my own? **Has my life fed other lives unnoticed or unknown yet, in its rising and passing?** Is my vigilance as constant as any wilderness creature, in trying to healthily preserve and nourish my own spirit?

In reaching to create positive answers, life giving life offers a beautiful collective way.

Awareness.

In the narrow period we call "history," much mention has been made of one difference between humanity and other species: consciousness. It's an awareness of self and situation said to distinguish us. No argument in nature denies a difference; our intellect has developed and turned in unique directions. **We are different from other creatures, yes; but not more aware.** Our difference can be described just as easily by a lost awareness as well as by a present one.

Creatures still fully absorbed in the daily wild struggle have, by necessity, a heightened awareness through senses we've let dim. The vigilance of

every hawk and fox, even every neighborhood squirrel, deer and spider, is relentlessly attuned to tiny details of sense. The sights, sounds and smells are essential to staying alive, for them. Their resulting consciousness of the surrounding clues of nature, and to the instinctive responses so intimately attached, is exquisite against our own.

Our intellect instead analyzes nature from a safe distance. It studies, names, classifies and otherwise contains it separately. All too often in the process, our awareness turns away from the sensations: the acute awareness of the smell of decaying leaves in the fall; the sound of a lizard's motion as it skitters through the leaves; the slight turnings of wind and weather and whatever else we miss, which apparently give such strong clues about when to migrate, burrow, hatch young, shed skin, and the like; when even to move in any given moment to stay alive in greater harmony with the weave. Is it any wonder so many feel so lost and disconnected in the society of our own creation?

When lost in concrete and conscious thought, I've learned not to seek answers in analysis and paved corners. Instead I return to a place of sensation in the outside air; a place of untamed creatures who watch me intently if we cross. I breathe as consciously as possible. Whatever question about work or family or whatever I might be unsuccessfully asking, I find I can lead myself to the answer by asking apparently unrelated questions.

How does this flower smell? How does today's rain feel against my chilled face? Where is the wind from, and who does it carry overhead, sharing the day? I let instinct rather than plan move my feet, and when my sense awareness settles in, answers to decisions and ways of being present themselves without needing to be sought.

Even a single neighborhood spider has the wisdom to teach us this path of awareness—if we are but aware enough to relearn.

The Color of Peace.

Blur your eyes for a moment. We spend most of our time aching to see more clearly—but there are some kinds of vision not available to the crisply sighted.

Lost in the sharpness of details, and in the meanings of lettering we can read too well, the colors and their own silent language may vanish from awareness.

Ah, the blossoming hues of spring, which sing with the brilliance
of bird song! They do still catch our eye. And the wistful blaze of fall,
with the leaves going out in glory before returning to more subdued soil.
Yes, most of us still notice if the orbits of our footpaths take us there. Yet
color integrates into our lives in ways of which we often
abandon awareness.

Color has more meaning and integration in the wild. The natural world speaks through color, with both flashing radiance and gentle green artistry. Its contrasts are at least as varied as our own neon urban palette. The **wild, brilliant color often has message,** beyond the message of beauty, which is message enough. A brightly colored creature may signify poison to its predators. One who needs more hiding evolves into perfect blending with the surroundings—attaining harmony and invisibility in one stroke of color.

Color's range is enormous: but in any natural scene—from the harshest deserts and ice fields to the most expressive impressionist field of wildflowers—**nature's composition has balance and harmony. It usually has artistic simplicity as well,** with a harmonizing blend of tones that inspire clear moods.

A forest of young spring green is the color of peace. A wildflower carpet is all the colors of exuberance and joy. A white mountain towering above is the color of silent prayer; the color of humility and reverence. A vista stretching endlessly below is a patchwork of the moods of introspection.

The natural scenes blend with enough clarity of palette to allow clear feeling to rise within us. We know this truth of color, at the core. We feel the sensations rise in the wild. We feel when the color scheme of our living room, too, is restful or stressful to the mood. We feel the calming effect of

green plants in our midst. We learn the message of red as danger—a place to stop. We even know, though we may try to keep ignorance, that it's a message of disconnection and disintegration written on the urban landscape with color. It's a chaos of hues, placed with insufficient regard for the landscape or each other to achieve compositional harmony. No camouflage, no coherent brilliance in total. No place to either belong or blend in. Uncertainty sets in, of where to go and how to be. We grow imbalanced and restless without a surrounding of the green color of peace.

How much nature teaches us about the deep function of beauty! Of building our lives and inner selves in a context of the harmony of colors! So blur your eyes once more, and let nature speak its spectral masterpiece, as a guide to the tone of our lives.

Perseverance.

Do not despair. Even the smallest shoot begins by knowing this, pushing its virgin leaves from the soil.

There's tremendous strength in tenaciousness—not the jerk-and-lift strength of a muscle-bound mover, but the long-term quiet strength of solid will. That kind of strength builds a life in improbable places: it cracks hostile sidewalks, overcomes precarious cliffs and relentless winds. It may be a silent strength given little recognition day to day, but it's lasting strength, always available. When my own will gets worn, nothing restores it more than seeing the tiny power of the smallest shoots around me, volunteering their lives in driveway cracks and building shadows. I seek them then.

Tenacious will grows around us, unbidden, offering its strength to our awareness with all the constancy we could ask. Keep on, it says. Keep on with faith. You are surely as strong as the driveway grass; as capable as a cliffside tree. Keep on.

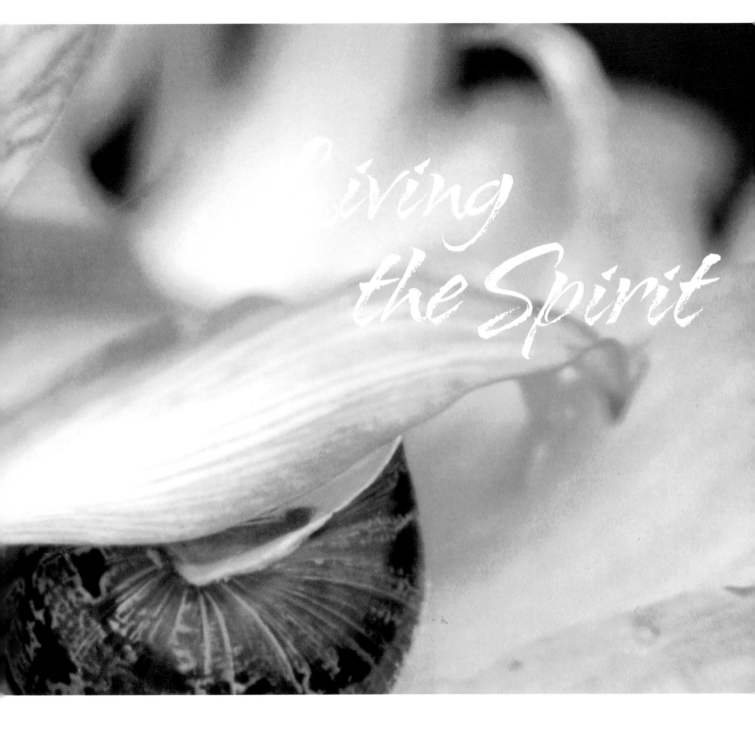

Living
the Spirit

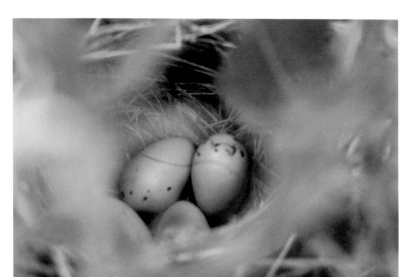

Home.

Whatever we are given is home. Whatever condition, whatever tiny piece of soil our soul is cast into: home. In the wild, there's no resistance to it. No wistful longing for some other ideal dwelling. There's only acceptance, and the hard struggle to adapt and blend.

There's a different context in the wild, of course: one without ghettos and freeways; without artificial vistas, either sheltering or inhospitable. The divergence of our path from the wild one has created a plasticized wilderness of its own.

The same imagination which can create prisons of thought or steel also can build a more conscious home, though—one which takes the natural lessons and adds another awareness to them. Our instinct recalls the astonishing wilderness dance of adapting and blending.

All flora and fauna have wildly creative, differing means of making their soil corner home, but their ways all work within the earth's greater system rather than imposing careless will against it. Call the animals' wild actions

instinct or humility, or even powerlessness and an absence of intellect. It still serves them perfectly. It serves the entirety of the integrated earth.

Blending in the wild, of course, serves as essential camouflage. It's a survival mechanism which we humans, with our ability to drive out the natural dangers, have forgetfully decided we don't need. We have the luxury, it seems, to live in stark contrast to the land. We can survive in places of harsh angles and unnatural shapes. We can survive chaos and imbalance. What we've discovered, though—whether or not the conscious awareness breaks surface—is that **blending is the key not only to survival, but also to calm and harmony.** When we clash with our context, the chaos and imbalance slip into our souls. Stress, we call it. That chaos and

imbalance can come from many sources; but our individual and collective home is a key one. The anger of cities; the frequent alienation of citizens there from each other—there are roots of this in the lost art of blending.

Blending well does not take riches or technology, especially in a healthy ecosystem. The animal architects of the world have proven this since the earth spawned them—and almost all animals are architects, with their holes, nests, burrows, dens, tunnels, dams, mounds, honeycombs, and more.

Tribal societies all over the world have also proven for tens of thousands of years that this translates to the human world. Straw-bale house builders still prove it now, among others. If you can build at all, you can dig foundations into the soil's steadier temperature for warmth. You can face your windows to the arc of the sun for natural heat and light. You can shape and color your walls in ways which suit the land. Again, this is what wild animals have always done, with no money and only the materials close at hand.

Most of us, though, don't find such natural design opportunity easy to come by. The corners we're given are established: fixed city blocks, or rural surroundings where the land has been substantially altered. This is a well-used world. Living in harmony with the natural ways has become a more challenging task. Not only do we have to be conscious of creating harmony with what immediately surrounds us; we also have to create harmony with the natural world that has been layered over. **To restore our connection to natural ways, we often have to blend with what is no longer near.** We have to use the same potent imagination which has removed the wilderness to find ways to reintegrate small elements of it into our homes.

Nothing is more key to this reconnection than light. Some creatures evolved for darkness; but we're not among them. Born to the surface of land, above ground and sea, we're at home in the fullness of daylight. The morning light was meant to pace our day. So what's more important in a home than windows which allow the morning light in?

Windows need to open, too: for if anything is more essential than light, it's the air the light scatters through. Without its freshness, we too go stale, wither, and disappear. Our presence and sharpness directly correlate to the

clarity of the air which we breathe. **Not only are air and light primary in our home, they** *are* **home.**

Green is home, too. In the wild, we evolved with it as our constant companion; it's still the color of peace. A single growing sprig is enough to connect to that essence with, and there's no home in which we can survive where some sort of plant can't. There's no dwelling in which we can't bring other earthen elements in, too: wood, water, life.

If even the tiniest creature of another species can be intentionally brought to share the space—from goldfish to house cat—through that other soul a connection can be made to other ways of being; to the balance of ways and perspectives the natural world abundantly offers. And even if, by circumstance or allergy or landlord's decree, no creature can be invited in, no worry—they will come in anyway.

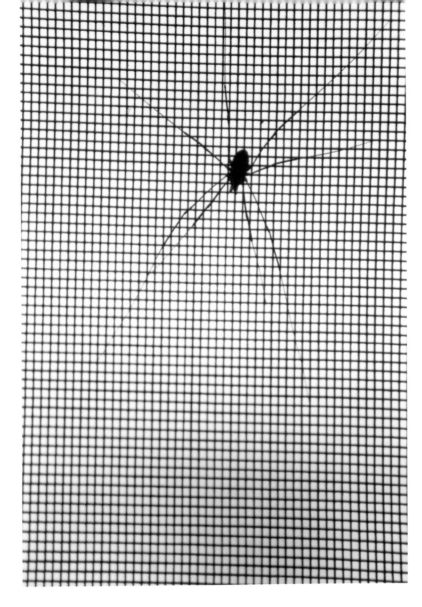

The spiders and moths and other tiny creatures find their way into our homes, not only regardless of our efforts, but despite them. Nature comes in to remind us again that **the small corners of home are not ours alone; they are always shared.** Even there, there are no impenetrable ceilings, no impermeable floors; no true separation. Wilderness still enfolds us, in the corners of home.

Surroundings.

That the feeling of solidity and clarity is called "groundedness" is no mere linguistic accident. The ground we touch, and what it touches in us, is what gives us that feeling. **If we don't touch the real ground or don't notice the touch, the grace of it inside soon vanishes.** So our footfalls in the territories around our homes are as vital as the ones within them. Adaptation and blending are key there, still, as back when homes were mere territories too.

Our territories may be paved and public now, beyond our doors. We can affect them, even then, if only by praying for that grass which splits the sidewalk.

Even a single blade of grass is enough to inspire a root of groundedness. A single flower through a fence is as beautiful as any in a field.

We can encourage each blade; each pioneering blossom. We can thank the weeds for pushing through the crumbling front steps, and breathe in the sense of connection they offer to the wilderness in our own souls. In those few sprigs is life giving life, and the color of peace. There, perseverance, awareness, and groundedness. No floors, no ceilings. Never mind the traffic.

If you have open ground to be with, no matter how small or how carved by fences, you are lucky and rich. Your adaptation and blending will be easier—your symbiosis with the soil.

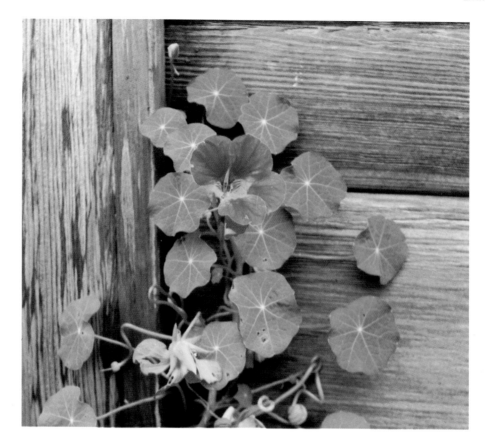

Nature never asked us to tend it, though; only to exist within it as it tended itself. The land's natural ecosystem was not, and is not, dependent upon human gardeners—and that's a great relief. The most natural surrounding is the most grounding; and also the least work. It will reappear, over time, if we just let it.

Indeed, what's natural for the local land? It's that which belongs there, and that with which we should blend. If it's not there any longer, perhaps it can be returned to the soil; and if it's returned well, it will thrive on its own, if the ecosystem around it is still intact enough. It may not be what you would choose to look at. But it is what belongs. And you belong too, by now. You grew up as a part of your landscape.

What belongs does shift, over time, and we're far from the first to alter our landscape. The ant colony in the sand hill; the wasp's nest in the oak; endless evidences exist. There are homes and sculpted surroundings everywhere in nature, with as much design as a craftsman's house. And consciously or not, many creatures encourage the plants they feed on: birds who spread berry seeds are gardeners too.

Keep abundance simple; perhaps that's all nature's example says. Keep groundedness modest. A simple surrounding is all we require. Modify it if it serves the earth, and you. There's great peace in gardening, after all. There's sanctuary in a greenhouse.

I saw a sign that spoke to this, while at a Buddhist retreat at a Catholic center. The sign sat quietly among the ever-shifting forms of plants and flowers. Its message waited patiently for all comers:

"The kiss of the sun for pardon
The song of the birds for mirth
You're nearer God's heart in a garden
Than anywhere else on earth"

Groundedness. Divinity. The color of peace. All in one small patch of dirt.

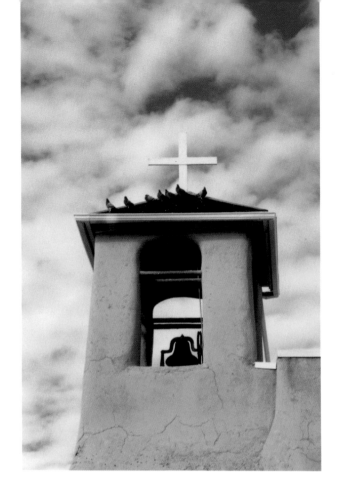

Religion.

To look into nature deeply, beyond humanity, is to see spirit everywhere and religion nowhere. **Pigeons may flock to the church roof, but they do not worship there.** Religion, as we know it, is a purely human means of grasping to understand the greater meaning and order—an order we can sense but not understand with completeness. We're given just enough intellect and awareness to fathom the depth of the sky; to analyze the connection between species; to look both inward and outward in a way unique to this planet. In this state, we seem to wish to shape our reverence as well as the order itself.

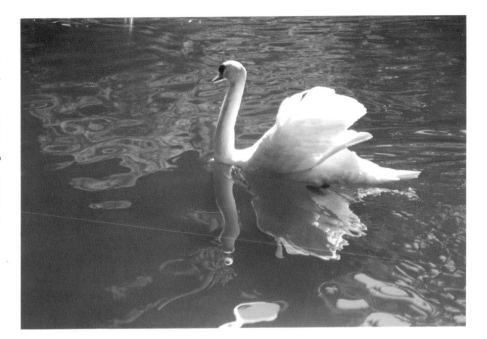

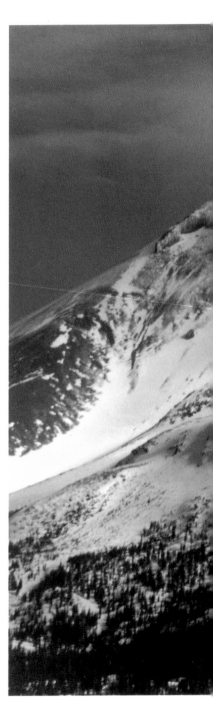

In doing so, we've created concepts and systems of worship which are unique. There are no chipmunks building altars or defining deities, heavens and hells. They are only digging holes for shelter, and sensing the seasons in their own perceptive way.

The human temptation is to label other creatures' perceptions as lesser—even though we constantly marvel at, for example, the migration knowledge of the geese which just passed as I wrote this, or the sophisticated web-spinning skills of the corner spider, also working even now. What of the sensitivity of the emperor moths who can sense each other a mile away? And how is it that other moth caterpillars in Costa Rica can perfectly mimic the look of a viper? The creatures of the wild have heightened senses which our own perceptions are not party to. More than most modern humans, they're in pure touch with the deep spirit of nature some call divine—yet they are not religious. Yet also, they may miss divinity we feel.

Can a swan perceive its beauty; the great order within and beyond its feathers' curve?

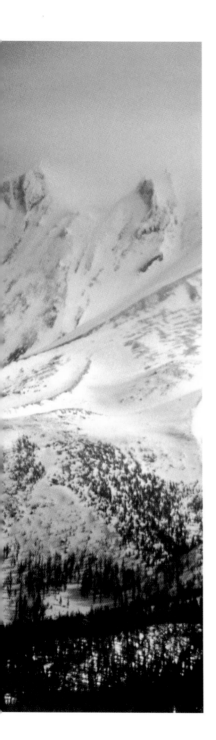

In light of this, what does nature say about religion? Must we reject these systems of belief and worship as artifice, simply because only the human animal defines them?

I don't believe so. We've risen from—are part of—the natural soil. Our thoughts and feelings have risen from us, in turn, and our conceptions of higher spirit. In some ways, we've seen more deeply, more consciously into nature's ways than any other species on this planet—even in the process of disconnecting from those ways. Every human religion—even ones bent by their followers far from their graceful ideals—are thus a part of nature. Different faiths can coexist as different species can, with harmony and conflict each part of the balance. In order to serve both the earth and the individual, however, a religion must harmonize with the natural systems from which it has risen. **Though there are many paths up the mountain, those paths must all respect the mountain.**

In cultivating that reverence, faith can take as its cue the unspoken diversity of nature: the astonishing array of living forms and ways of being. Faith can recognize that difference is not only acceptable to nature; it's necessary for balance. Nature leaves room for a great variety of religions: for their cohesion, their conflict, and the realization that conflict is often illusion.

Creation or evolution? That debate has raged for millennia with the fervor of war. But any artist or burrow digger knows: every creation constantly evolves. Even when it's "finished," be it this book or a gopher hole, it leads to new creations; it fades, crumbles or grows mold. It creates new forms then, itself. It inspires others. **Creation and evolution are one and the same,** within and beyond any who are part of it.

That's only my voice, though, as wide-eyed and wondering as another small boy in church. Listen: the geese are calling again now, too, as I write, saying something entirely different than me, and at least as meaningful. Their wise voice is as full of spirit as mine.

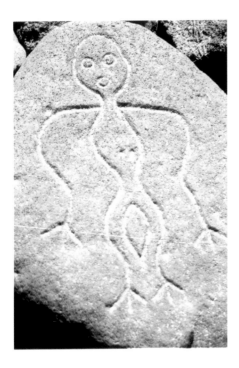

Sex and Intimacy.

Sex carries spirit forth. It's earned reverence for eons.
Without it, most life would die in one generation. It's that simple. It's also highly complex.

In the wilderness, sexuality has almost as many forms of expression as there are forms of spirit and flesh. Some are bizarre, to our eye; even unthinkable. The palolo worm in the waters of Fuji, for example, breaks off its hind end and releases its sex cells—male or female—to float to the surface at the moon's third quarter each October. Would you do that?

Meanwhile, The nephila spider in the American tropics has such a size difference between mates—the female can be a thousand times the size of the male—that the female doesn't notice or care when the male deposits his sperm. Some species apparently can reproduce without sex for several generations, including some termites, aphids and wasps. In some lizard species,

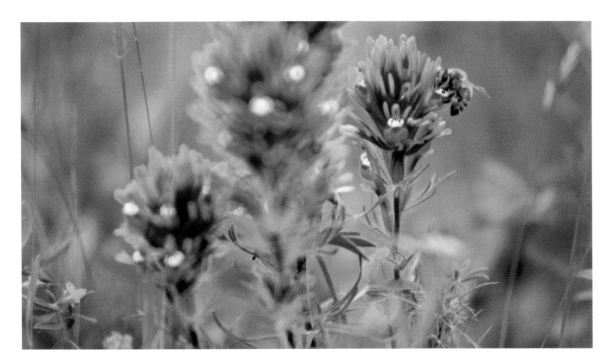

all individuals are female, and continuance is through a more subtle cellular connection. Some fish born female later become male and mate. The boundaries of sex are as subtle as the boundaries of life itself.

We may not call the connection sexual as the merging crosses into, say, the pollination of plants. In some way, though, the essential need for close touch with another being for continuance carries through. **The press of a bee into a flower is another sweet rhythmic merging, a making of love.**

It's a painful mystery why even the most natural sexuality can have such violence attached. The sexual animal world is not generally one of sensitive caresses and whispered gratitude, even though there are also steady graces of mating in some species that make our marriage contracts seem like hollow, enforced commitments. The patterns and messages offer both refuge and conflict; they seem admirable to abhorrent—even within close species and places. At the nearest lake, the intense faithfulness of geese exists alongside

the predatory fight-and-rape sex of ducks. Farther away, bull elephant seals herd as many as a hundred females together onto a beach, and (not unlike some bar scenes) mate forcefully with as many females as they can, as the females attempt to escape to the sea. Hercules beetles follow a similar strategy. And in species where there the male is significantly larger, force tends to be the rule rather than persuasion. Very few mammals are monogamous for life—though very few mammals need to be, for their young are unlikely to be as dependent as ours for so long.

It's easy to pass judgment on other creatures for not making our mating choices. But our standards are not the ones by which the world was designed. Spirit has found successful continuance through such patterns. If nature is the essence of wisdom, acceptance of loveless sex seems necessary. It isn't good or bad, beyond the bounds of our self-designed critical minds. It just is. And in many wild cases, sex still provides pleasure.

In our context, sex and continuance have evolved more subtle meanings. **Our continuance is not just in the creation of new young physical bodies. It's also in the spirit and beliefs we instill.** It's what our shared touch engenders in our partner, ourselves and

our children. Through sex, we have evolved a new form of life—emotional intimacy. To raise children—and to raise each other—we must be aware of the emotional intimacy we are creating.

Here in our new human wilderness, **sex is life giving life as surely as eating is,** and our awareness of its subtle effects must be heightened. It must feed you to be touched by me. It must feed me as well, in body, mind and spirit. Via touch, what we create together must feed the whole around us—remembering that our touch is passed on to the world. A person nourished by sex of deep spirit has a radiance. They carry peace and aliveness that affects all they interact with. Conversely, the sexually frustrated are frequently disconnected, alienated, and entirely too grumpy.

In the wild, sex lacks shyness or shame. Sex may not always have poetry and subtlety, there, but neither does it have human inhibition. No need to look as far as the animal kingdom to see inhibition's absence, of course. You may only need to look within. Many modern men and women, and ancients from tribal to Tantric, have lived with great sexual freedom.

Along the sensual path, both free and constricted, the ways of human sex and intimacy have been extremely divergent. Among the Nyinba people of Nepal, a woman frequently has several husbands; the opposite of the Mormons, where men have often had several wives. The nomadic Woodabe tribe in West Africa, although centered on emotion and relationship, have ways of beginning and ending marriage alien to ours—and ritualized, sanctioned philandering during annual celebrations. Nature has not judged these ways—for within their own contexts, the successful continuance of spirit has resulted.

We all exist in unique contexts. And as much as we must flow with nature as a whole, we must also flow with that segment which is our culture, our home, our family. We can't choose our sexual model indiscriminately from the ways of animals, tribes or neighbors. Doing so carelessly can perpetuate violence in our continuance. If violence was natural in the human sexual context, evolution appears to have removed that necessity. We can release it now, along with shame and inhibition.

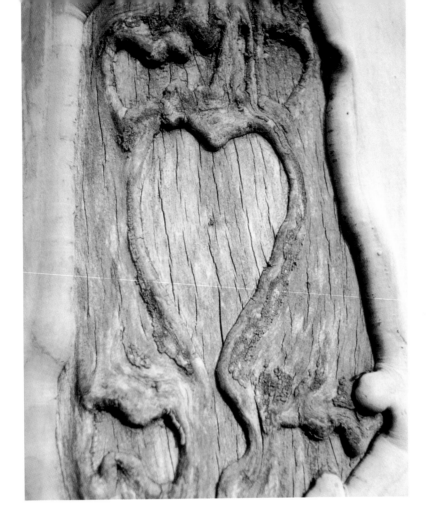

Can our declarations of love be more than a defacement, of our lovers' souls or the bark we carve memories on? Can our continuance be better than an infliction?

If nature's wild variance hasn't provided us with an easy model to guide our own sexual behavior by, it has at least provided us with endless models to question—each an opportunity for perspective. It has also provided us with enough gifts of heart and awareness to allow us to merge those gifts with physical touch into an unparalleled path of sexual grace and kindness.

No shame, no inhibition. Breathing in, love is a part of me. Breathing out, I'm a part of love.

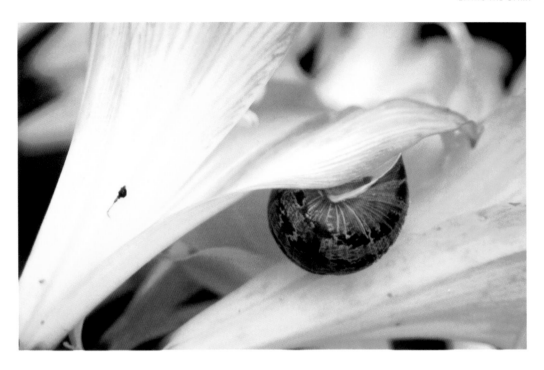

Clothes.

It's nakedly obvious: no other species adorns itself with cloth and other finery for reasons of style or shame. True, hermit crabs wear other species' discarded shells—a natural suit of armor; a mobile home with no money down. Snails and turtles find a shell around them; birds and reptiles are born from within shells as well. But those shells are homes or pieces of self more than an adornment, like a suit and tie.

Be naked, and be beautiful. This is what nature seems to say. Be unashamed of your body just as you are unashamed of sex. Yet nature adds that, in your naked beauty, you must be supremely adapted to your environment for survival. If you aren't, you will die, with no tears shed by the soil.

Somehow, we have grown soft and poorly protected in our raw state. We have evolved away from being able to be naked in the cold wind of a Chicago winter; or else we have moved ourselves out of our native habitats.

We are still beautiful, but we have moved and changed. There are many times, social customs aside, when clothing is necessary for life.

It takes nakedness to remember how often clothing is *not* necessary: how heavy, cumbersome and inconvenient clothing can be. It restricts free movement. It weighs you down. It cuts off sensation. It keeps either sweat or rain from drying quickly. It takes endless time to make, buy, change, wash, dry, iron, repair, get rid of, get more. It's expensive. Clothing even promotes division between people, by giving messages about economic status, political views, or other measures of difference. **Nakedness is a great equalizer.** I know this from having lived at a clothing-optional hot springs. Nudity changes the entire human dynamic in ways which can be healthy, positive, and not laden with inappropriate sexual overtones. It is indeed quite natural.

It isn't easy to return to nakedness, though—it's too powerful, and stirs too many emotions in those who are not prepared for it. Being naked is likely to get you arrested or assaulted, despite that you were born that way. But wherever people have respectfully agreed to allow themselves to be free, we can remember to be the wild, unadorned creatures we are, alive to the nuances of sensation—open to each other. It's all underneath the thin threads we've woven.

Family and Community.

In the wild, deep dedication exists; yet family and community in nature are often harsh, complex, and filled with violent struggles for dominance that ought to teach us why human peace on earth has proven impossible to achieve. Domestic violence, guerrilla action and survivalist wars are not limited to our own species. Neither violence nor abandonment are abhorrent to nature, within their instinctive context.

In countless species, instinct does breed noble action. The immovable, fierce protectiveness of a mother bear for her cubs, for instance; the same fearless protectiveness in the small red-winged blackbirds that used to dive at me on my bicycle, to repel me from the all-precious nest. The single-minded work ethic of many species' parents, for whom feeding the young becomes the all-consuming focus. Or the heartbreaking loyalty of a goose I saw, standing steadfastly next to its dead mate in freeway traffic, preferring its own mortal danger to abandonment, even in death.

But would any of us choose the model of some spider species, with one partner killing and eating the other after mating? Would we watch and emulate a pride of lions, refusing to let a wounded member re-enter the clan after it has first slinked off alone to heal? Would we emulate other lion

behavior, where a male sometimes invades another pride and kills the cubs of his vanquished rival, before mating anew with their mother? Would we take permission from the birds to not take our young back into the nest, if they're touched by another species? And what of the many species where one parent—often but not always the male—is gone from the moment of birth, or even conception? It's dangerous to selectively take permission from other species for human habits.

When it comes to natural family and community, both harmony and struggle are deeper than our sight. Our concept of enemies, for instance, is as limited in vision as our concept of peace. In truth, **all enemies are family too**—an essential part of the universal community. In that sense, they're not enemies at all. We're indebted to rattlesnakes and grizzly bears, bumblebees and mosquitoes: to all that keep the chain whole, even as they bite, sting or eat us.

Enemies temper our numbers, and we struggle with the loss of temperance these days. Where are our enemies now when we need them for our health? We have broken their communities, and so in their absence they break ours.

Along with the necessity of enemies, in nature, there is alliance. That is a comfort. Alliance is everywhere, across all boundaries of species: Gorillas pick fleas off of each other. Birds find food from the leftover kills of cheetahs. Cleaner wrasse fish scour the teeth of larger groupers. Beetles on a Costa Rican mouse keep fleas down—the more beetles on the mouse, the healthier it tends to be. Sunfish surface to allow gulls to remove fish lice from them. Oxpecker birds remove ticks from giraffes. Humans raise sheep. It's endless.

Creative alliance marks the survival struggle of the world. It introduces new meaning into family and community; it introduces what we have evolved into friendship. We've added this richness, and its new presence seems natural—more evidence that, in some odd way, evolution is still working.

In order for friendship to meet the test of true alliance, though—and alliance is a tougher standard—it must truly serve you, me and the earth. Alliance may be based on survival necessity and convenience, but it isn't merely self-serving. Neither is it inconsistent or fickle; it needs to be reliable to the death. It's constant over generations, over species. **Alliance, like all forms of family and community, needs to be as constant as the faithful stars.**

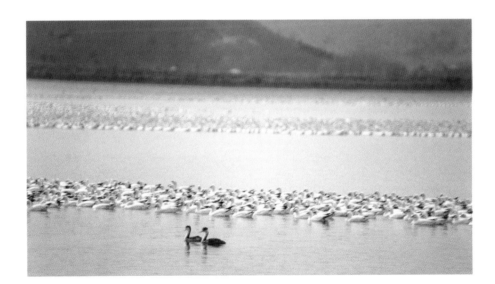

The allies and enemies with the grand family even reach beyond ani-
mate creatures. Look at the forests; at a dancing creature there some might
not call alive: fire. It's violent, and lethal. But an enemy? Remove fire from
the forests, and they choke with growth—until, inevitably, fire breaks
through anyway at a level of intensity vastly, unnaturally greater. Fire's life
is at the center of family.

In fact, what *isn't* at the center of family? Remove a predator species
and watch its prey multiply until its own food supply is exhausted. Remove
hundreds of species or even the forest itself, and watch disease strike the
remover. Or remove water. Remove dirt. Remove darkness or light. Remove
the very dance of struggle that's alive in its own way, as fire is. Remove any
thread and nature will speak through imbalance that it's all family and com-
munity. Equal harm and gain are always traded, in the end, between victor
and vanquished. We're all one, even as we're divided and warring to the
death. Nature sees no conflict in this. Nature calls this harmony. This earth
is your hard family. There is no divorce.

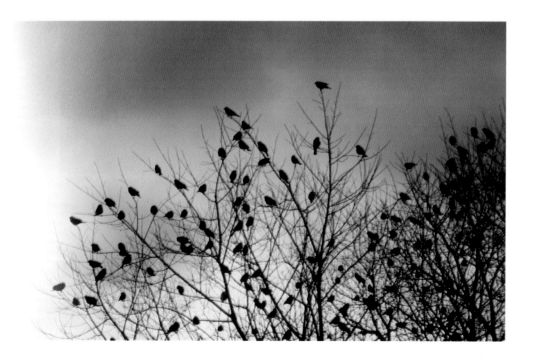

Exercise.

Motion tunes the soul. It's such a natural and instinctive tuning that in most
species and situations, the truth of it remains below explicit awareness. In the
wilderness, the survival struggle is so physical, so constant, so taxing, that
exercise beyond it is unnecessary. **Wolves and zebras, insects and
birds, have no need for treadmills and weight rooms.** They
are in top physical shape—or, quickly, they are dead. Exercise and strong
physical health, in the wild, are as essential as air and water: for predators, to
hunt food; for prey, to keep from becoming it. For most species, both.

In captivity—which is essentially where most of us are living—we
have the luxury of slow collapse. We have the temptations of ease, especially
in the affluent countries. And with ease comes the slow dulling of senses and
perception; subtle fadings of clarity and perception, a loss of feelings and

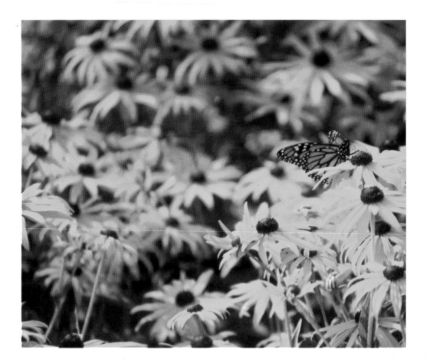

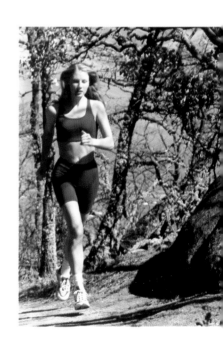

sensations—including the awareness of the fade. The person who slowly slides out of physical condition is unlikely to fully notice or recall the difference, until the spark of conditioning returns.

In the human world, the glow of an athlete is obvious. It's more than grace on a field, a track, a court of contention. It's a vibrant strength and aliveness that also translates to a glow of sharpness and sensation. It may not be coupled with an acute sensitivity in other areas of life—some might incorrectly, stereotypically argue the opposite—but there is an undeniable physical robustness that athleticism brings. In the wilderness, that robustness is essential. There, **every living creature is an athlete. Even every butterfly shows its suppleness and strength.** The luxury of old age is rarely permitted in the wild.

Even for those of us born into a life of shelter, of banished predators, everything changes with exercise. Physically, strength and immune system are enhanced. Longevity's likelihood is increased. Other benefits ensue,

from calmer sleep to better digestion. Emotionally, more clarity and connection are attained. A better balance of moods prevails. Awareness is heightened. It's clear and obvious—but only if a person has visited both conditioned and sluggish states with awareness. Not that slugs are as poorly conditioned and dull as our word has come to mean: slugs, too, are as athletic as they need to be.

What does the wild teach us about exercise, then, beyond its centrality? Perhaps it's that integrative exercise is the ideal. For exercise, as the wilderness defines it, is part of daily life. It's the motion of daily necessity; not a separate antidote to the work day. It's hard breathing and pure sweat done in clean air with the raw earth underfoot.

Aliveness arising from our own exercise is still most acute in a fresh natural setting. What we breathe in becomes us; cleaner exercise means more purity of heart. There is no substitute for untainted sweat.

In cageless urban zoos, though, we live a life of compromise, and nature teaches that we must work within what we're given. Only very fortunate humans have integrative wilderness exercise built into their day—and even then, that exercise may be imbalanced or involved in work which is ravaging that very wilderness. That distorted context can more than undo the internal gain. Exercise, too, must serve the earth.

In my own life, the best integrative exercise is in my mode of travel. My bicycle gives me air and conditioning, if not air conditioning, and close connection to the weather in the process of going to work. The exercise warms me more than the car heater would, even in the winter cold. And the daily presence of work assures the constancy of discipline in exercise. There are even side benefits of cost, simplicity, and environmental sensitivity.

But the choice is not so clear for many. Our lives have structures of distance in them now which are defined by

the limits of our machines rather than the needs of our bodies. Workplace and home are scattered across freeway distances—or runways and fiber optic cables. There's danger and difficulty in integrative exercise in contexts which not only don't give it primacy, but create unreasonable barriers against it. Communal fitness centers seem sadly necessary in places, with machines designed to restore to body and soul what other machines have successfully removed. For many, they're the best blessing among hard urban compromises. Answers and compromises are as individual as the barriers with which you're faced.

In your motion, are you flowing like water? Are you floating, in your own way through air? You must move to know; and not via any machine which removes you from the clear air in which the answers rest. Cars, in particular, via barriered steel, closed windows, loud engines and stereos, protect us from what we're seeking. The machines taking us places are also taking us away from them. Machines cannot take us where machines have never been. Machines, with their roar, only drown the message imparted by the lives of wilderness creatures—that **grace and beauty are, of necessity, found through sweat.** Motion is still the essence of living.

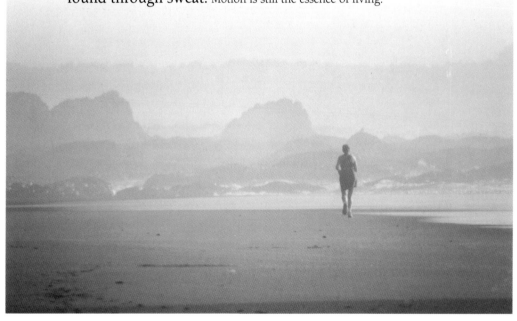

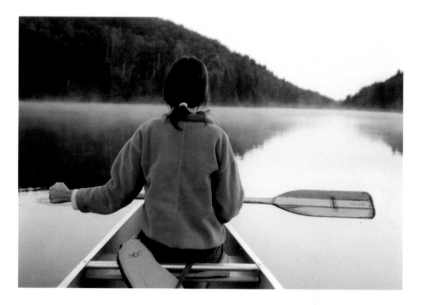

Stillness.

As much as motion, stillness tunes the soul. As much as athletic quickness, stillness is wild survival. Stillness allows both predator and prey the invisibility and vigilance the unsheltered life requires. It allows blending, so as to be unseen. It also allows vision—for the absence of motion allows a different level of sight to rise into sense awareness. Details, small motions—a variety of essential minutia rise to surface through still eyes. Other senses, too, may sharpen with the distraction of motion removed. Awareness, the ultimate quest, comes to the fore once more.

You, however, may be extremely busy, moving quickly, very far from the wilderness, and not likely to blend in even if completely still. Where, in the chaos of responsibilities and mechanized motions, can we each find stillness?

At last I've begun to see that stillness is available not only between periods of hurry, but within them. Small creatures of the forest and shoreline know this; their instincts can switch them from sleep to vigilance, from flight to perfect stillness, so quickly that there appears no transitional stress.

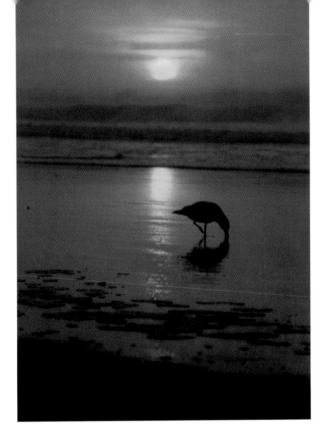

Instantly, they're watching. Instantly, they're gone. They don't wait to get two weeks off in December before becoming vigilant and still, or before traveling. They can't afford that, and it has nothing to do with money.

Wild creatures expend energy wisely, and conserve it when they can. **To find all the stillness possible is one of wild creatures' daily tasks.** It's survivalist wisdom, not laziness. Their watchful stillness is a state of being which appears very close to what we call meditation. Like meditation, it's a state of heightened clarity and observation; not any sort of remove or disappearance. In fact, it's quite the opposite.

Even when creatures are most still, they're still breathing. They're breathing slowly, deeply, without hurry, then—at least, as long as they haven't just finished running for dear life. Breathing is a basic skill which transcends all borders of species. Breath pervades every movement, every action; it's not ended by any pace, frantic or slow.

For a creature in the wild, breathing effectively is life and death. In stillness, not being still enough can mean death. Breathing calmly is part of that. In motion, not breathing purely and deeply enough can mean death too, for ineffective breath quickly means exhausted motion, which means being caught and eaten. We, who are removed from most life-and-death predatory conflicts, are often out of shape in this regard. We often neglect to notice that, though every close creature's call can remind us.

Fortunately, we have new predators to help us. Our predators are small and subtle: they're often our own moods or mechanical inventions. Our predators and our time for stillness often come as one, just as in the wild, where the time of greatest peril is often the most critical one in which to be still. You can find both predator and stillness when the traffic light is red; or when the traffic jam is stopped. When the person beside you is angrily shouting, your stillness is in listening. You have

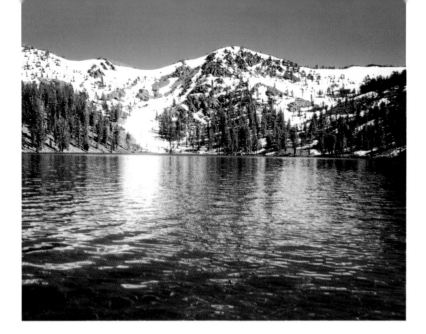

to breathe anyway, then. You might as well breathe deeply. When the telephone rings, you can breathe before you pick it up. You can breathe again when the computer makes you wait—consciously, deeply, slowly. There doesn't even have to be a moment between thoughts to accomplish it. It requires no extra effort. In fact, using the breath to create slow moments takes less energy than living otherwise—it takes away frantic elements; it makes the day less taxing. It conserves vital energy, just as in the wild. On an instinctive level, all creatures know: **we must create stillness, as often as we find it.**

Here, where our new predators are subtle, so are our rewards. We've come to live on sensitive levels; and stillness allows high understanding of our own context and ourselves. Feelings too are wild creatures which only fully venture forth when it is safe to do so. If they're surrounded by a turbulence of action—either physical or mental—they remain at least partially below the surface of awareness.

That mantra returns to remind me: *Breathing in, the wind is a part of me. Breathing out, I am a part of the wind.* Stillness is inside; stillness is outside. Stillness is where there's no difference between the two. And inside stillness is the center of soul.

Balance

Balance is a marvel. Mere physical balance alone is a miracle of complex elements—one usually destroyed by thinking about it. **Balance in motion is best done by instinct,** and the human sense of it has been encumbered merely by consciousness of its existence. Not to mention its encumbrance by business suits, spiked heels, heavy consumer packages and cell phones pressed to the ear.

In comparison, the confident balance of wild creatures is sobering: even creatures adapted to urban zones. Squirrels doing telephone wire gymnastics show as much grace in balance as any savanna gazelle. The nearest backyard raccoon has steadiness and solidity in its unwavering eyes equal to the most

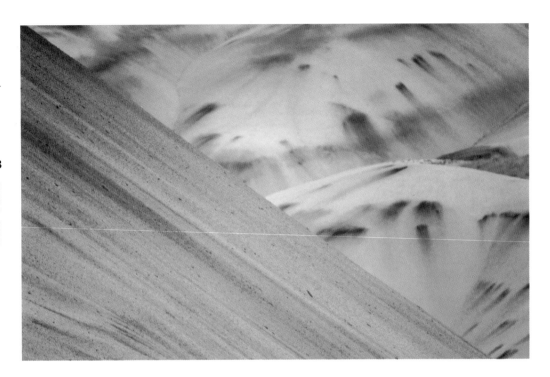

remote and wary wolf's gaze. We, meanwhile, stumble over our own curbs
and avert our eyes from loved ones and strangers alike.

Our struggle with physical balance is a reflection of our loss of balance
in deeper ways. Struggle is understandable, with so many elements to bal-
ance in our lives. To the wilderness existence, we've added all manner of
responsibilities and passions, relationships and ways of being. The strain of
it is due to excessive evolutionary success, not failure.

If it's any comfort, we're far from alone in losing balance this way.
Creatures from elephants to locusts have had excessive temporary success
within their ecosystems, bringing temporary local ruin. The earth has always
recovered from it, though, returning to balance in a new form. It surely will
again. **Balance has no limit to its forms.**

The earth's deep, returning balance is a balance of limitless patience; of
instinctive trust in the process. It's a balance of acceptance. Practicing it our-
selves in even a rigid concrete environment is now our challenge.

In an electric society, even maintaining balance between dark and light can be a huge challenge. With electricity comes the constant temptation of light; with light, the temptation of action; with action, the loss of rest; and with the loss of rest, the eventual loss of most everything. Pure light is as vital as pure dark; and there's an artificial constancy on some strange middle ground, when it comes to modern illumination.

Many times, our balance of stillness and motion needs as much restoration as our shadows and light. Our motion is usually mechanized, and without benefit of exercise. Our stillness is usually incomplete, without the pureness of rest to which healthy exertion leads. In returning from this, we must be mindful of stillness and motion in the simple, focused way animals are: when you rest, rest. When you move, move.

The balance of our emotions is tied to this balance of light, of motion, of everything. Emotions narrow into a busy gray if light and dark disappear; if stillness and motion also lose definition. They need their own corresponding extremes. Pure constant joy is no more possible than pure constant daylight. And pure constant pain is no more natural than endless running without rest. **To regain balance—to regain joy—we must also regain pain.**

Slow down, take walks in the woods, work less, feel all the feelings, let go the thoughts; let instincts nurture themselves, as instincts will do. Sounds idyllic—and serenity awaits along that path. It's just that the serenity includes pain, hardship, darkness, and other weighty elements. And if there are many layers of buried pains and forgotten joys inside, even the presence of external serenity can bring internal demons screaming forth before true serenity and balance are restored. Most people who've done extended meditations or retreats have experienced this.

Without distraction, the intensity of true silence makes itself known. Every inside whisper becomes a screaming roar. Dreams became vivid, significant, clear. Every relationship—good or bad—heightens. Those who survive the onslaught of sensation prosper and permanently change. It's a challenge, though, to reach this point. It's so much easier to hide in

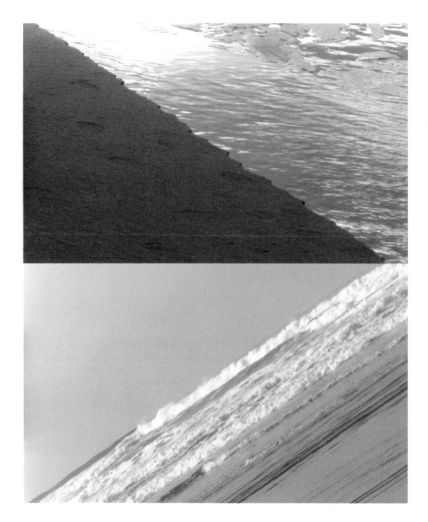

the unstable equilibrium of civilized, mechanized "balance," which is not really civil or balanced at all.

True balance asks us to respect the call of winter for hibernation; to resist the vice of the incandescent late-night glow. It also asks us to heed the active call of the long summer warmth. We must not lose the pull of the moon, the depth of the sky, to our narrow, short roofs and the forgetting they induce. These have to be given higher priority than the other tasks and temptations, if balance is to return.

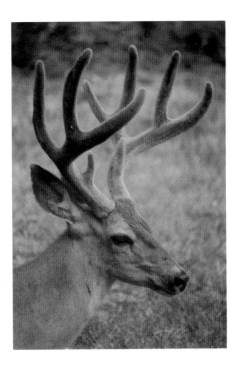

Work.

Survival is the only career in the wilderness; awareness, the task that centers it. With each new breath comes a requirement of vigilance. It's relentless, but it also has its rewards. It explains why the greatest richness in our own lives is found not by attainment, but by deep awareness of what we already have, and what we experience.

If enlightenment is a state of perfect awareness and no interfering mind, then the enlightenment so many have sought is essentially a return to the wild state of perception. **Enlightenment is what the wild animals already have.**

What does this say about our concept of work? Clearly that our own career is awareness, too. We just have a shifted context in which to apply those latent skills—to release the enlightenment we already have, buried in our animal instincts.

What we define as "work" is only an added surface layer.

Work, as we know it, is a unique luxury. It's also an exceptional burden.

Work is a luxury because, with less daily worry than most species about what other creature might eat us, we're freer to learn chosen skills from carpentry to science to art; to create, explore, and apply our discoveries. Our choices are numerous, if not limitless. It's an opportunity of experience no earthly species before us has ever had, and its joyful extravagance is not to be taken lightly.

Yet the paths and patterns along which we've chosen to direct this luxury have lacked sufficient awareness of their effects on ourselves, each other and the world. We've created and assigned importance to tasks disconnected from our needs and the planet's—tasks requiring or permitting great suffering.

Questing to fill the heart in the working world, we challenge the mind and test the body—harder, faster, with intellect more than perception. If the heart becomes fulfilled along a path so indirect, it's more accidental than not. And if the world is somehow improved, it's only narrowly so—as narrow as our focus.

Our methods of survival are indirect compared to hunting prey and sleeping under a tree: we study books, learn a trade, get hired by someone else to apply it (often as they see fit), be given paper in exchange for it, and give that paper to others in exchange for food, shelter and other basics, most of which have been obtained by our suppliers through another long indirect chain. These methods are so inefficient that we end up spending huge amounts of time to get basic needs of food and shelter met—often doing very unnatural, unpleasant things in the process.

Most people work far more, in fact, than hunters and gatherers and other so-called primitive people did.

And the overwhelming domination of these artificial, overwhelming work structures has made it difficult to exist beyond them. Work is, indeed, a burden of which no wild animal could conceive.

So, what does nature ask us to do, in our new context? Beyond the

cultivation of constant awareness, I believe it asks us to be conscious of the effects of work on our souls and the earth's. It asks us to choose simple work, do what we need to, and then spend our remaining time sitting on tree branches singing, or sunning ourselves on the rocks, or mating with our partners. That's not laziness; that's nature. Some lions are reputed to sleep up to nineteen hours a day; sloths twenty; koalas twenty-two. All have sex in mind. Now there's a version of enlightenment most people could live with!

Also, **nature silently expresses the dignity of service work.** Wild animals build no monuments, write no operas, discover no new principles of physics or medicine. Yet, in their work of feeding their young, of building homes out of the barest available material, or otherwise creatively living to see another day, they are the very model of grace and beauty. It's in the way they work, as well as in the simplicity of their tasks. They work with focus, attentiveness to detail, and without question of self-worth. They don't need external validation of their lives, their choices. We're capable of the same dignity in whatever tasks await us, if we are aware.

Education.

A diploma is never granted by the wilderness. A piece of paper such as that might be useful to line a nest with, or hide under, but it certainly isn't what education is, in nature. We know that, instinctively, before schoolhouses brick over such knowledge with facts. **Fortunately, schoolhouses crumble before instincts do.**

Many have said that education is the whole of personal experience; but nature goes further than that. With its remarkable ways of passing on detailed knowledge from generation to generation—be it ways of spawning, paths of migration, complex social rituals or simple burrow-building skills— nature shows education to be the whole of collected knowledge, shared across hundreds of generations without so much as one textbook. What you learn eventually becomes your descendants' instincts.

Meanwhile, in human nature, **young instincts contain wisdom repressed by adult consciousness.** Parents often find their children to be their greatest teachers.

True education is so broad, vast, and interconnected that the wilderness infers there is only one: the entirety of earth's knowledge and ways of being. Across all boundaries of species and time, myriad forms of knowledge all coalesce at a grand level—and if an accounting degree is somehow a useful contribution to that, well, so be it. It's better than leaves when the toilet paper runs out.

Money.

Creatures in the natural world don't even recognize the existence of money. Like a diploma, a dollar bill might be good insulation for a burrow, or provide a bored chameleon with a good camouflage challenge, but that's about it.

In the wild, what is of value is food, shelter, a mate; continuance through offspring. **Wilderness values are true family values; money is out of place within them.**

In the new human context, money has taken root like yellow star-thistle or any other non-native plant invader. Money has no natural enemies, and it has spread accordingly.

It's useful to play the money game to the point that doing so indirectly provides necessities of true meaning. Beyond that, though, nature's message remains succinct: money is of no value.

Ownership

Nothing is more natural than territoriality. Born into a space held by others or by openness, every creature's instinct is to occupy and defend a safe piece of it for awhile. Territoriality is an essential, useful and therefore beautiful element of life.

It's an instinct which colors our actions and creations, however, in ways less pure. **Our fences and walls often damage our space instead of protecting it.** This is reflected in that other creatures and plants do not recognize any boundaries of human "ownership." It's not because they know less—it's because they still know more.

In many modern minds, territoriality has been transformed into a belief in actual ownership of objects, creatures and land. To own is to control; to be in permanent charge of. Ownership is an illusory concept related to, but entirely different from, territoriality's temporary nature.

The wilderness never features the acquisition of material possessions as a primary goal, though it's occasionally done as a means to an end. For example, a few bower bird species collect leaves, berries, snail shells and

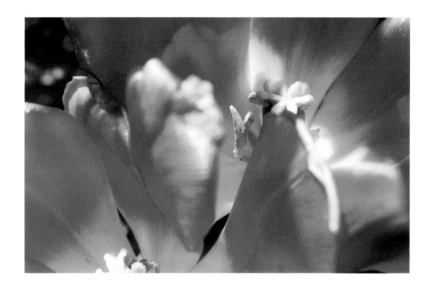

other items to impress mates—something akin to impressing your desired girlfriend with a hot new car—and in the case of both bower birds and humans, it sometimes seems to work. Sex and offspring may result; if so, it serves continuance in an indirect way. Still, it's not the leaves and berries that matter, and their collection is temporary. Animals may build homes, store food, and defend both, but the hoarding of objects as an end in itself is foreign to forest and sea. When a creature passes on, there are no attic piles to be dealt with by distressed relatives. Its home may quickly be occupied, its food and even its own body consumed; but there are no wills to defend in court; no pretenses that permanent control of items exists. At most, wild creatures are caretakers. And so are we. And **what we are caretakers of, could never be improved by our "ownership."**

Of course, ownership of other living creatures is absent in the wild too, even if territoriality is intense; even if animals fight possessively over mates; even though the wilderness is full of extremely controlling relationships. On the more symbiotic side, there are relationships which nearly parallel our farmer/herd animal relationships: Australian green tree ants, for example, not only milk blue oak butterfly caterpillars for their secretions, but also build them night shelters and chase off their predators—all of which the

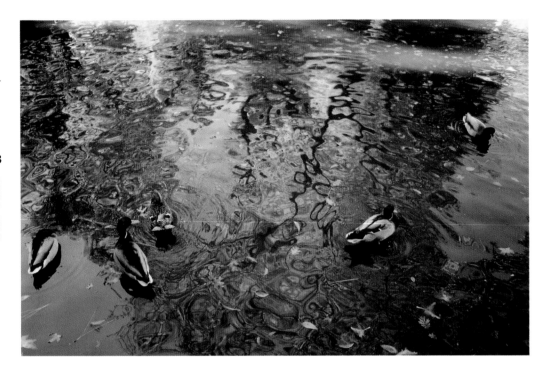

caterpillar encourages. Some types of hermit crabs actively place an anemone on their shells—the anemone's poison tentacles keep away fish and octopi that eat the crabs. The anemone may be bound to go where the hermit crab does, due to its place on the shell—but it is not owned, nonetheless. Even in cases where an interspecies relationship is brutal—such as wasps that paralyze caterpillars and flies as future food for their offspring, and then lay eggs upon them—it isn't ownership. It's just the hard, cruel dance of life giving life.

Ourselves, we keep work animals, food animals and pets—not so differently, perhaps, from hermit crabs, green tree ants and wasps. The relationships we create with animals may be equally symbiotic or cruel; they may temporarily be very controlling. But an animal can run or fly off, or act in ways which we're powerless to control or shift. It will pass on at times and in ways we can't direct. Our "ownership" of other creatures remains illusory, no matter how much we feed them.

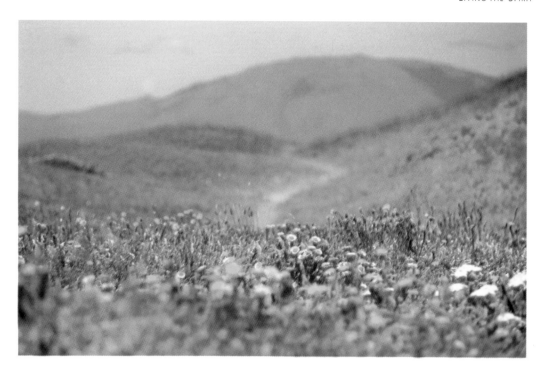

With wilderness creatures, we recognize we don't own them. But we seem to have difficulty extending this concept to the ground beneath their feet, even though they're inseparable from it. Only the land's life makes their life possible—and ours. How can we own that which has created us? Which was alive long before us, and will be long after we're gone? **Owning the land is like owning spirit itself: impossible.** No other species has fallen prey to such a transparent and self-centered illusion.

The ownership illusion is still prevalent, so—as with money—playing the game may be necessary at times. But it's still only a game. And releasing that burden of ownership is a great relief. We can walk the pastoral paths without needing to be in charge of them. All we're asked to do is defend our little territory, create our continuance, and go on our humble way.

Food.

Food is sustenance; its need a common thread linking all creatures. And since what living creatures eat is other life—be it vegetable or animal—that means **being eaten is as central to nature as eating is.** It means that being born and growing up for the sole purpose of becoming someone else's dinner is not only a valid reason for existence, it's an essential one. It's the ultimate service work in a world that requires it. That's a humbling remembrance for our species, which has carved out a place at the top of the food chain, and largely eliminated the chance of being eaten—the chance of doing true service.

Oh, the occasional shark or grizzly bear may get through the defenses; and there's nothing better than a cloud of mosquitoes to remind us that we can be food for the tiny as well as the mighty. But, in the current human existence, we are mostly in danger because of ourselves and each other—often for far less compelling reasons than because another creature needs to eat. Not being properly eaten, we are slowly eating each other, spirit first, and the world around us.

While we struggle with this, we still must eat; and nature knows something else about food. That is: food is simple, and directly from the earth. Food is not made in corporate factories by machines whose true product is profit. Food does not contain artificial additives or preservatives; nor is it engineered with magic tricks that scramble its genes. It is not packaged, not marketed, not even cultivated. It is provided by the grace of the growing earth.

Part of that grace is that the eaters must let the eaten flourish—if the eaten vanish, the eaters will too. **Food is to be cherished and nurtured; respected as well as swallowed.**

Nature seems to ask that we not do to food what would be an indignity if it was done to us. Being eaten is quite dignified: but being mixed with assorted harmful by-products, packed on a corporate assembly line into an insipid can, shipped for profit's sake to someone too disconnected from the source to see my life inside of the can—I'd find that undignified. It would also be dangerous to the eater: for when you become what you've eaten, how can you know what you're becoming if you don't know what, or whom, you've eaten?

Nature has never seen fit to allow that separation. In the wild, eating is intensely intimate. The eater almost always meets the eaten, most often alive. In that way nature keeps the respect and connection between souls. Nothing feeds you more than the dignity and purity of the eaten; and I, for one, want to remember that when it's my turn to become food instead of consuming it.

Health.

Health first grows wild, like the brilliance of spring.
Somehow we spring from the perfection of a seed. Then, when health
vanishes, everything else personal also disappears. Surely the creatures of
the wilderness instinctively know this. They must defend their health with
their lives—for it is their life.

Whether or not we're sufficiently aware of it, it's the same for those of
us in the tame or "civilized" world. What's different is one particular belief
about health.

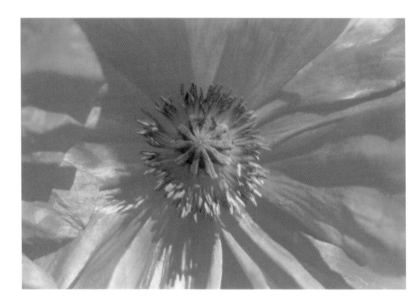

In the wilderness, **health is a gift given once. It's a single blossom bound to fade.** The body's natural defenses may allow recovery from minor illnesses and injuries. The body is a remarkable healer. Still, the wild offers no doctors, no miracle cures, no casts and surgeries and high-tech medical magic. If you break something, it's broken. If you contract something, you have it until it goes away itself or kills you.

The vast knowledge of healing we have been so clever to discover has given us great gifts of ease and peace of mind—and I, for one, would have been dead from cancer as a young man, without them. I, like endless others, have gratitude for modern medicine's charms. But I'm also aware that these same charms have, while restoring our health, come to erode our appreciation of it. Instead of viewing our health as a unique, cherished, irreplaceable gift, we have developed the view that health is more like a mechanical device which can be repaired an almost unlimited amount of times, no matter its condition.

The more miraculous and astute that medical knowledge becomes, the higher our expectations of repair rise, and the lower our appreciation of health sinks. The streets are now teeming with people who have abdicated

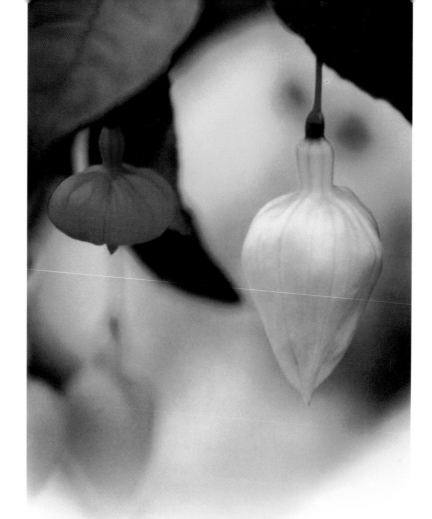

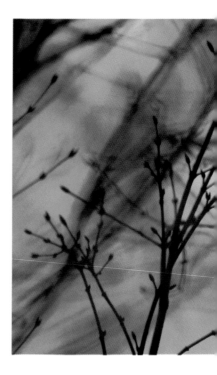

their responsibility to take care of their own health; who expect the medical system not only to be able to repair them, but to do so with little or no effort on their part—no matter what their lifestyle has contributed to injury or illness. That loss of a sense of personal responsibility, and of the vital fragility of health, is a great and unnecessary casualty of medical advances. Fortunately, nature is still here to remind us that the truth hasn't changed: health is a gift given once. **Health is a wild miracle, beside which our own creations pale.**

Individually, health is far more than a mere absence of illness; it's a holistic way of being affecting body, mind and spirit. And even holistic individual health, if pursued without regard to its effects on systemic health,

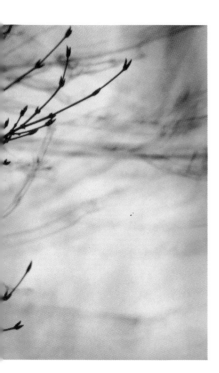

can be deeply unhealthy overall. **Health is not merely personal, separate from the health of others and the soil.** Just as there is only one education, there is only one health: that of the planet itself.

Our own fierce instincts for survival are a part of that health; our individual lives have a place in that balance. Threats to each of us have lessened, though, and our lifespans lengthened. Our individual health and survival chances have become so high that our collective survival overwhelms. The planet does not need us all, for its health.

Some of us must regain the acceptance of the weak and injured wild animal, who knows it must go back to the earth. Who is so gracious in not complaining of its painful part in that wild grace, when grace means passing on. There is wisdom in that weakness. Health is a gift; but so can death be, in the context of the greater continuance. It can be a gift from the individual to the earth that needs to reclaim the life; that needs one less life of that certain kind right now, to be restored to balance. It can be the hardest gift to accept the need to give, and the greatest.

Yes, health is a gift given once. It's a temporary gift, too, on a personal level. **Health must always be given back, in the end.** The individual always leaves it available for another, whose turn it is next to serve the balance by living. No individual owns health any more than they own spirit or the kiss of another soul. Health is entrusted to us to nurture for awhile, a brief while, before we go. Health is for us to fall humbly before, in reverence to it—each of us, its beautiful servants.

Music.

I think we all evolved from songbirds. In spirit, at least, I feel our connection. **Life itself is a rhythm, propelled by a percussive heartbeat, ceasing exactly when its music does.** Every human culture has evolved melody, spoken through rhythm—been moved and changed by this elemental force, music. What is it, though, and why is it so powerful? How can a sequence of tones move and change souls? Where in nature did it rise from? It remains a mystery even in a constantly musical world.

Music as we know it is as unique to humanity as emotional intimacy. Instruments, concertos and electric bands—these are new to the earth. Yes, birds sing, and other creatures communicate with noises and rhythms that

may qualify as music in their world, or ours. Is that an orchestra of crickets? Is that a backbeat in the percussion of woodpeckers? All sound is music, if you hear it that way; but are we the first to listen in those terms? The meanings and feelings of elemental wilderness cries are difficult to translate to human musical terms.

Music is a language found; another mysterious life form risen from nature. Its borders and beginnings are as indefinable as the borders and beginnings of life. But alive it is—rich, deep, and vital beyond measure. It evolves along with emotion and environment; but here it is now, to stay. It's uniquely human, perhaps; but it isn't unnatural. It's too deep and universally moving to be a mere surface game, like money or ownership.

Music is also becoming a language lost, though. As pure and essential as it has been throughout history, it's becoming secondhand in technological cultures. No creatures before us—and few humans either—expected others to communicate for them, in a musical language or any other. Until recent decades, voice and melody were something that originated within, in the moment; then, ethereally and ephemerally… gone. No lion ever played back another's roar when it had the roaring feeling. Nature's language of sound is inherently personal. And even now, in some human cultures—particularly African—everyone is still a musician. There, **making music is as fundamental as laughing.** The nature in this quietly implies that music is still instinctive inside each of us; a dormant seed, merely waiting for the right conditions to grow.

As with health, so with music: the more we have technologically to support it, to create and reproduce it in abundance, the less we seem to value it, and the more we expect others to make ours for us. Music is not passive, nature says through every creature's voice. Music is primal and felt with your whole animalistic body. It's precious, and exists only in the moment it's made and experienced. If music became only electronically reproduced, it would be extinct. Then every recording would be like a drawing of a dinosaur: beautiful, fascinating and compelling; but ultimately thin, and sad with loss.

Music is a species that can be easily saved, though: just open your mouth, and sing.

Conflict.

Conflict has its handprint on everything. It's as inherent in the
natural life as breathing; it's the key to the grand design. It's not just the
predator/prey dance, either: regardless of other species, every animal left
alone against the elements finds conflict with the conditions of the planet
that have made its existence possible. Winter storms, violent heat, shudder-
ing earth, a disappearance of water—such things can make a creature seem
to be at personal war, at times, with the very earth.

Even when there is no external conflict with other species or climatic
conditions, there is struggle with members of the same species: a competi-
tion for mates, for food, for territory. And even beyond this is the conflict
within: the struggles of bacteria and viruses and other tiny lives inside that a
single body hosts, coincides with, or battles with on a level too microscopic
for awareness to reach. Beyond even this, there is also the conflict with time
itself—the force that moves through all, and ultimately conquers every life
to which it has given rise.

Another conflict has been created by humans, between the essential
nature of conflict, and our desire to find a life free of it. We have slowly
removed ourselves from the immediacy of the food chain, to protect ourselves

from the conflict of predator and prey. We find then that we still seem to need those battles, and turn against our own to find them, on streets and battlefields. We have reached to shelter ourselves from the elements—only to find that our remove from them creates a deeper conflict with our basic need to be connected to them. **An emptiness of soul begins to develop inside our shelter—a conflict with ourselves.**

Through medicine and other means of safety we have dedicated our narrow brilliance to removing the conflict against time and inner invaders. We are older, and in one view healthier, than ever before. And again, we find that the result is only a greater conflict between our species and the earth. Overburdened by our swelling presence, it fights back with new disease and difficulty.

The more we try to separate from each of the conflicts, the more we find new conflicts of inner soul, wondering what our purpose is, where we belong, who we are. This becomes a conflict so fundamental that it appears to be a crisis unprecedented in the history of earthly evolution. What other species has ever felt at a loss for its purpose? **When every lowly fly knows what we have forgotten, how can it be seen as lowly?**

Is it any wonder the peace on earth we've endlessly longed for has remained elusive? Peace on earth, defined as an absence of conflict, appears

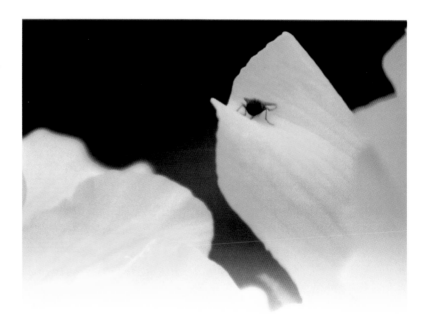

to have never existed. It seems to be fundamentally in conflict with the entire process of evolution. It's in conflict with the nature of soul.

One reply to our peace prayers echoes through the great cathedral: **the way to peace is in the acceptance of conflict.** Peace is not an idyllic external circumstance; those don't exist in nature. Peace is a calm inner way of being within the conflict at hand, whatever it may be. Being with it, fully, right here, right now.

The primary natural means of conflict resolution is simple: fight, until the physically dominant one prevails. When the fight is between species, the life giving life of sustenance battles, the fight is usually to the death. When the conflict is between members of the same species, for territory, food or mates, the fights are most frequently done with the minimal amount of necessary injury. There are exceptions—some monkeys, as well as lions, kill the cubs of their vanquished rivals after taking their mates—but intraspecies conflict in nature is often stylized, ritualized. Actual blows are frequently

avoided by ritual displays of size and strength in which dominance is estab-
lished; and injurious blows are a last escalation. There is no evolutionary
advantage in having members of a species kill each other off; there are
enough external challenges already.

The natural means of conflict resolution has often been called barbaric.
Surely we have advanced beyond this, human reasoning runs. But consider
the opposite perspective. Nature's conflicts and fights are elegantly decided
with only the strength of the individual; the weapon of the body itself. By this
means, the potential damage of conflict remains limited, and the stronger,
healthier life is always favored. This is evolutionary refinement, not brutality.

**By inventing other weapons, we have destabilized
nature's graceful, delicate dance of conflict.** We have vastly
increased the amount of damage that an individual can do in a conflict.
An individual with the right weapon can now ruin whole populations or
ecosystems.

We can create ruin not just with intentional weapons, whether explo-
sive, chemical or biological; also with weapons such as cars, chainsaws and
oil drills. They, too, are lethal to other species and our own; and the collec-
tive damage is massive. It's a vast increase in barbarity.

Paradoxically, another trouble provides proof evolution is still work-
ing—albeit in a skewed way. Survival of the fittest now means the fittest
weapons survive, rather than the fittest creatures. It's as if our dangerous
tools, from missiles to cars to computer viruses, have become dominant life
forms with their own quest for continuance. This means our conflicts don't
select for the best and healthiest lives, or for the life of the planet. They
select instead for the life of the weapons; for whomever happens to be hold-
ing them—which means money may be the most dangerous weapon of all,
given its acquisitive power. Money, although of no value to nature, is per-
haps the species currently finding the greatest evolutionary success.

Fortunately, it's also true that we've evolved other means of resolving
conflicts which are individually peaceful, creative and without obvious
injury. It's part of the unique dance of emotional intimacy humanity has
developed. From meditative introspection to whispered loving speech to

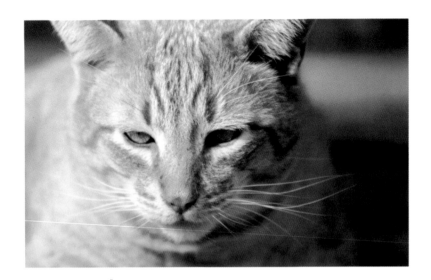

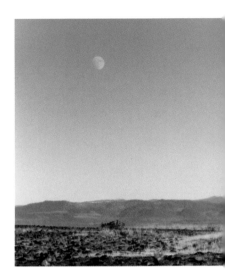

business mediation, our capacity for communication and understanding has increased immeasurably. **Love, too, is an evolving species as effective as any in its quest for continuance.** Look at all that it has survived so far. It can even transcend boundaries of species.

Note that nature has no laws, let alone lawyers. It does have ways of being which enforce themselves simply by evolving and existing. But nature's ways are not laws, as we've defined laws, for laws can be broken— they're rarely even written unless they already have been broken or likely will be. Nature's ways, by contrast, just are. All creatures inherently live within them. Our laws are simply odd little conceptions, in comparison, and very narrow ones at that. They're mere notions of currently socially acceptable behavior that shift wildly in the winds of ideas. **Our laws do not exist in any landscape without us.**

Human laws begin by serving the ones who make them—much more than they serve the ones ruled by them. (This too is different from nature, which serves itself holistically.) Then laws begin to evolve in their own right, like another weapon, another species. Laws begin to primarily serve themselves. They reproduce profusely in their search for continuance—laws begetting more and more laws until society chokes on their abundance.

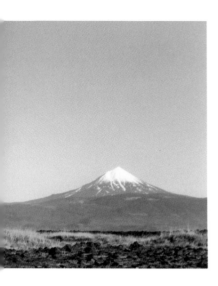

The courts, which started out as a means for conflict resolution, have instead become a means for making conflicts endless. A single dispute can now drag on for many agonizing years, even decades, where it would have been settled in the dust in twenty minutes, in so-called primitive times. Yes, we have forgotten what every fly knows.

Nature still offers the same simple answer to all of this: If conflict is unavoidable, put your weapons down, and fight. Naked. Right now.
Let your conflicts and their resolutions be as stark and clear as the desert dunes.

Given our current context, though, we can't return to the ways of the wilderness and find harmony with the human standard. Things have changed too much, even if it's our own doing. In our modern circumstances, the situations of conflict we face daily are so shifted that our instinctive responses have become ineffective or inappropriate, as strong as they may still be. This is one of the most stressful conflicts of all. The slow development of instinct could not possibly keep pace with the fast-edit motions of

modern change—leaving us with natural responses ill-equipped to deal with the surface world we ourselves have created. For example, male aggression is not a character flaw, but a wilderness instinct out of context, finding its distorted expression in predatory business practices, bar fights, rapes and wars; needing transformation into a more apt force.

Adapt or die, nature still says. Why should that message change now? Sudden changes of condition, from sweetness to harshness and back, have characterized the earthly eras of ice and fire and pristine green springtime. These conditions have never given benefit of exception from this to any chosen species, regardless of its abundance or intelligence. **If what we must adapt to is, in part, ourselves, so be it. That is part of nature too.**

Fortunately all our tools of physics and spirit also arise from nature. From meditation to mediation, these tools of transformation offer tremendous power in service to better awareness. They have their own evolution, within and beyond us. They offer such unprecedented assistance in our effort of adaptation that success seems in grasp, if we can evolve with them. Success will mean transformation of our relationship to conflict in a search for peace—a true peace which welcomes all the conflict and struggle we are ever graced with.

When we transform ourselves, the world itself will transform around us if it needs to. Our new ways will become instincts, over generations and millennia, passed down above and below the line of consciousness. There is nothing to worry about. We will either transform in ways which serve ourselves and the greater balance, in which case we will prosper on healthy ground; or we will not, in which case we will die and the ground will work on its own to transform, restore, and grow healthy once more. Nature does not appear worried by us: it has much more time than we do. It has much more life that just ours. It has not only survived, but lovingly mothered, much greater conflict. It appears at peace with that. So peace on earth is here.

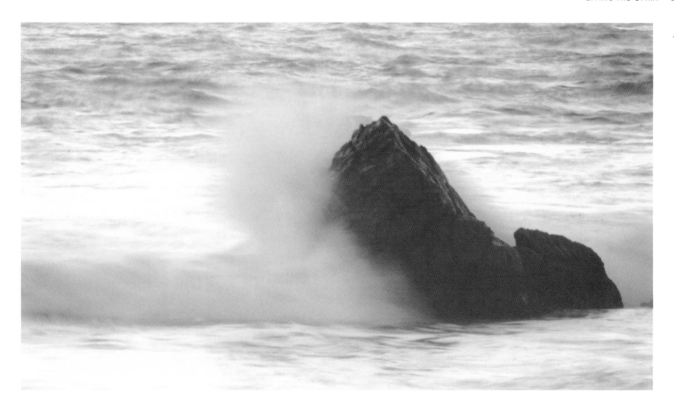

Sleep and Dreams.

Sleep is the ocean from which we all rise. From its vast and universal tide we have crawled out onto this land of consciousness. We break surface from the depths, coming into an awareness we call life. We pause in its daily rhythms to return more lightly to rest, merging again with the tide by night, rising with light to repeat the cycle until at last our final return beneath the waves of rest.

In the wild world, the need for sleep is as primal as the need for breath, water and food. Pure sleep is necessary for pure awakening. The two equal opposites make a unified, beautiful whole. So if nature has any message regarding sleep, it is: don't disturb it. Sleep is sacred. Sleep is vital to enlightenment—and to mere survival.

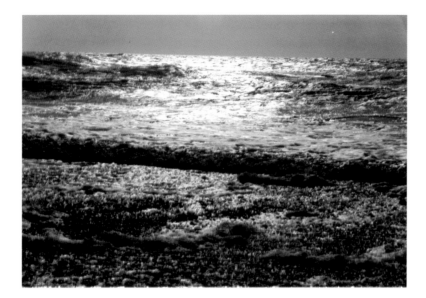

The ways in which we push back the edges of sleep, from night electricity to morning caffeine, steal the sharpness of perception we use them to seek. Nothing replaces sleep. No creature of the wild resists it except in case of life threat. Wilderness sleep must also be easily risen from, however, as returning from it coherently in a instant is often necessary for survival too. Wild sleep remains extremely close to waking, however deep it may be.

Sleep is not a disappearance from perception, either. It's just a shift into other realms of it. **Sleep is not an illusion. Sleep is the truth.** Sleep is also not an unfortunate waste of time that could be better spent working or mowing the lawn. It's an essential, sweet, restorative, luxurious and often enlightening time of life. Our first-hand experience of other animals' dreams is absent, and even our inferred knowledge of them is small; but we know they exist in some parallel way. And we know that our own dreams are radiant; vital; illuminating. In times more mystical and less scientific, dreams were given great credence as guides; as messages from the greater heavens. They were not diminished or discarded as "only a dream." Sleep is one eye; waking is the other. Together they combine to provide a vision of deeper dimension.

Dreams and visions don't always remain within sleep or beyond it, either. **Sometimes vision coalesces in a place that transcends all perceived boundaries.** A night-time dream triggers a daytime understanding; the perceptions of daylight shape the images of night. And at times half-waking, on the shore where the waves of rest tumble, the images which arise can be the most intuitive; the most vividly truthful of all.

Consider a half-dream vision I recently had. It was mid-day, but my consciousness was thickly fogged despite my motion through the room. A woman passed by me, and in my dreamtime state I could barely greet her. Yet when I looked at her I saw something clear and spectacular.

In just the hairs on her skin and in all the blood motion implied within her, I could see that the earth in its entirety was contained within her. In a holographic way, all the earth's ways were imprinted in her formation. Every wisdom of instinct, every shift of seasons, every sprig of growth, every belief and spiritual path had their possibility and beauty connected to her, and thus partly contained in her. I could see in the shadow of her skin hairs that all the world's potential for darkness was within her too—all the natural violence and pain. She was vast and complete, and in that way, exactly like the rest of us. She was, in her own way, a perfect wave risen on the ocean of rest. She was the current embodiment of the earth itself.

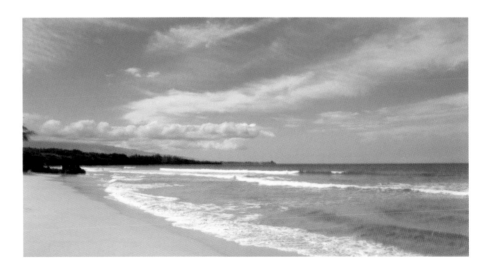

Had I been fully awake, I never would have seen it so clearly. Yet the more awake I then became, the more the image deepened and remained.

Never more than in that moment have I felt this lesson of wild grace: to recognize the wholeness within, and to draw on that vision. **That is the goal: to be like the earth is, with its patient ability to absorb all beauty and injury, all violence and rust.** That endless patience is part of the earth's seemingly limitless capacity to be with all forms of conflict, and to transform it all into the next step of evolution. It's the ultimate grace, and our ultimate challenge to live up to that leadership, alone and as one.

Even in the dreamtime there's no way to know what else might be in the remarkable space beyond this small spinning sphere. Still, as the earth is contained in us, so too must the universe be contained in the earth. Its ways are all latently coded there. Wild grace extends to levels forever beyond us; yet its spirit is entirely present within us. It's equally in the ant that now pauses upon your knee. It's in the small stone which has traveled millions of years before resting in your shoe. It's even in the deep airless black we've mislabeled as emptiness. It's inherent everywhere.

The ebb and flow is beyond resistance, and the great tide of sleep will once again claim us for good some day. We don't know all dimensions of what we call death, and what may be beyond it. Take comfort, though: we do know that **the more our awareness expands, the more the apparent horizons recede.** When we turn our gaze to the stars, the extensive beauty of the galaxies opens. No ceilings. When we turn our gaze to the microscopic, ever smaller wonders appear. No floors. When we turn inside to open the gaze to spirit, we find no boundaries. We find only deeper dimensions of this great cathedral.

Mostly, the limits we find are only our own. All creatures model this for us. When we look at them crawling, swimming and sprouting beside us, we see that there are broad levels of life and meaning which are beyond their perception. That gnat crawling across this page will never understand this text—though it may smell and see the ink in ways that you or I will never feel. The deep sea fish will never even conceive of sunshine. The oak tree never conceives of running.

Nature asks us to understand that we cannot know, beyond a point; and demonstrates through other creatures' limits that solving the workings of the universe is not necessary at all, to flow naturally within it. Instinct, as limitless as spirit, has always been enough. It still is.

No, we don't need to understand. It's the same with passing back into the final ocean of rest. Our spiritual conceptions of the great sleep have abundant variety and depth, from reincarnation to heaven to the purest black ink of eternal silence. In some way, they are all part of the truth. It's enough that nature speaks of the vitality of our passing. Wild death is inevitable but not useless nor tragic. The dying fern feeds the soil; the rotting redwood log hosts new growth; the mouse feeds the snake which catches it; the fallen wildebeest carcass feeds insect and mammal alike. **Passing is a great gift of renewal to the earth.** It strengthens a later new tide that births fresh awareness.

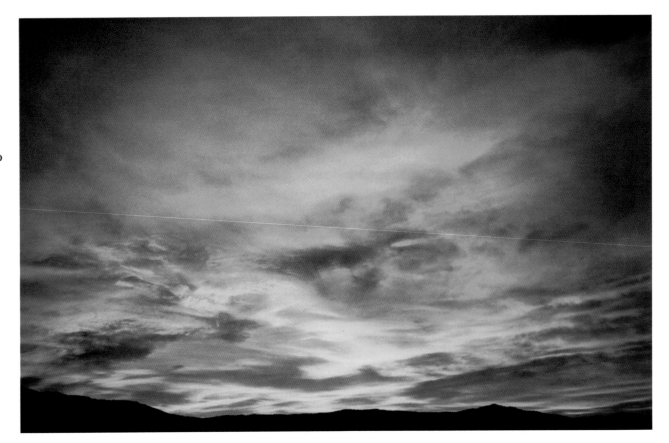

When it's time to be absorbed back into that tide, the wisdom of the wilderness tells us to surrender; to make sure that our being feeds life as it passes on. That is continuance, and selfless comfort. That is the endless beauty the spirit of nature offers, without any perceptible limits of time. In the final release of self is the key to nature's apparent immortality. If that is all our awareness can reach to see, that is enough. If we can just perceive the endlessness of beauty, its most natural form will be realized within us. Look: that endless beauty is evolving even now—another sunrise around and within you before sleep comes. **In the balance of wild grace, a sunrise is an ending as easily as a beginning, perfect either way.**

A Photographic Key.

As writer and photographer, I've noticed how different most people's reactions are to the two forms. With words, most question me about the creation itself: the sentiments, observations and poetry involved. They don't ask what kind of word processor or pen I use. With photography, most questions are technical: What kind of camera do I use? Film? Filters?

The key to both forms is the same, though: vision. Technique and technical skills are essential to a point. But particularly these days, when cameras are so sophisticated and effective, the largest difference between photographers comes from within. It's the degree to which our skills of seeing are developed. Photography and writing are all about seeing, at the core, just like music is all about listening. Photography, too, is particularly about *being there*. This book is a sample of what I've seen, where I've been.

Most of the photos in this book are available as custom signed enlargements, framed or unframed. Some may also be available on calendars, as photocards, or in other forms. For more information, visit **www.wildgrace.org** or e-mail **eric@wildgrace.org**. Please use the image number listed in parentheses for each photo when ordering.

Cover

Nature's touch is available anywhere; the main cloud photo was taken from inside my apartment of the time in Ashland, Oregon. (#394.1-13)

Elements

Contents pages, left. Fall near the lower duck pond in Ashland's Lithia Park. (#543-24)

Contents pages, inset. A spider web in Lithia Park, part of a vast population of creatures there that largely goes unnoticed—part of the vast web which connects us all. (#333-15a)

Sensing the Spirit

A Preface, A Prayer

P3. Buddha in winter in Santa Fe, New Mexico, living the goal of equanimity with all weather. (#339-2)

In the Cathedral

P4-5. This southern Oregon madrone bark reminds me of stained glass. To me, it truly represents the cathedral. (#131-1)

P6, upper left. See cover description above. (#394.1-13)

P6-7. A pine cone bravely making its stand on an Oregon tennis court. (#425.8)

P7, right. Flowers in the wind in Bear Valley, California, near Wilbur Hot Springs, where I was resident artist, and where my photographic eyes truly opened. (#352-21)

No Ceilings

P8-9. From Upper Table Rock near Medford, Oregon, once a Native American sacred place with another name. The moon and Mt. McLaughlin, too, also layered with other names through the ages. (#437-24a)

P9. The moon above Wilbur Hot Springs, always bright and kind. (#46-9)

P10. Moonrise over Green Lake in California's eastern Sierras. (#591-1)

P11. This isn't actually a distant galaxy, but that's what I see when I look at this reflection from the Illinois River. Small patterns repeat the large. (#192-16)

No Floors

P12, left. I think of these two red Hawaiian flowers as a romantic couple. (#408-1)

P12-13. I rarely know the names of plants. Was it Monet who said that in order to begin to see, you must forget the name of the thing you're looking at? (#422-2)

P13, right. Ah, to fly freely through a world of flowers many times our size. (#362-5)

P14. I do know the name of Magnolia blossoms. The world is an impressionist painting, upon close examination. Perhaps Monet was actually a realist photographer. (#347-20)

P15, left. Taken in the Mendocino Coast Botanical Gardens in California just after September 11, 2001. The world was still beautiful in most places, even then. (#534-17)

P15, right. A picture of a gnat. The leaf is incidental. (#383-11)

P16-17. The simplicity of a strong young tree in winter, along the Pacific Crest Trail near Grouse Gap. (#169-15)

P17. This web has as much music in it, to me, as the CD it resembles. (#333-14a)

Flowing

P18. Ashland's Lithia Park, with spring trees reflected. (#213-5)

P19, left. Ashland Creek again. Fall now, just as vivid. (#196-7)

P19, right. Middle Fork, Applegate River, near the artificial Oregon/California border. A special trail with four strong seasonal personalities. (#195-9)

P20. The waves at Laupahoehoe Point on the big island of Hawaii are a rough and wild crowd, to be admired but respected for their power to carve or kill as well as nourish. (#83-10)

P21. More fall colors above and below surface in Ashland Creek. (#148-11)

P22, left. Sunrise at Wilbur Hot Springs, the waterbugs awake before me. (#37-18)

P22, right. Autumn reflection in a local Japanese garden. (#142-10)

P23. Tidepool on California's Lost Coast, distant from the spoil of highways. (#356-24)

Floating

P24. Birds above Hyatt Lake, so together. (#208-16)

Silent Support

P25. I usually feel cradled like this leaf, in nature—as long as I'm warm enough, have enough to eat and no creature is gnawing on me. (#430-17)

P26. Along the dirt road where this butterfly was, I often bicycle up the mountain. One day, a butterfly circled me for almost a mile as I climbed on my ride. I felt blessed. (#111-24)

P26-27. Haze brings magic to a set of Oregon ridges—nearly a Japanese painting. (#436-13)

P28. Union Creek, near Crater Lake in Oregon. Experimental zoom. (#250-7)

P29, left. Just off the coast of Crescent City, California, almost the entire world population of Aleutian geese rests and feeds for six weeks in spring, before heading north. Once almost extinct, they're now over forty thousand strong—most all of which fly off one rock at dawn each day. These are seven of them. (#458-14)

P29, right. Neighborhood leaves, polished by fall rains. (#372-8)

The Faith of Stones

P30, left. Coastal weather shapes the sculptures of the Oregon coast at Bandon. (#548-4)

P30–31. At the top of Castle Crags, near Mt. Shasta in California. Up is easier than down. (#234.14)

P31, right. Seaside stones at Smith River, as far north as California goes. (#458-18)

P32, left. A simple stone on a weathered table at Breitenbush Hot Springs (#357-11)

P32, right. Underwater stones, never left alone by the tides. (#354-6)

P33. The temple of Castle Crags from the Pacific Crest Trail. (#394.2-5)

P34. The Pecos ruins, east of Santa Fe. The builders of the churches collided with native spirituality, creating ruins from the start. (#376-1)

P35. Every sunset on Mt. Shasta is different. They're all sacred. (#299-5)

Life Giving Life

P36. This bald eagle was in the Lower Klamath Wildlife Refuge, part of the largest winter gathering of bald eagles in the contiguous forty-eight states. He let me get so close that we first thought he was injured; but thirty seconds later he flew. (#167-17)

P37. A duck painted in fall colors on a "canvas" of water. (#249-9)

P38. This fellow, on California's Lost Coast, was unafraid of humans. Too bad he should know better. (#355-11)

P39, left. Butterfly on thistle in a former Oregon orchard, returning to forest. A century later, the settlers' roses, lilacs and mint have gone wild nearby. (#333-26)

P39, right. This bee on an echinacea flower was at my mother's house. The first photo I took on the first trip home with my partner Jane. (#333-13)

P40. The journey of monarchs across thousands of migratory miles each year remains one of the world's subtle wonders. Even in their pause, they're wonder enough. (#607-8)

Awareness

P41. Spider in his dream home in Ashland—one of the last affordable dwellings in town. (#302-1)

P42. These leaves are floating on nearly still water in Lithia Park's Japanese garden. Some of them are gingko leaves—an herb reputed to make you think more clearly. Worked for me, just looking at them. (#370-20)

P42–43. Mendocino calla lilly, gracing the headlands' cliffs. (#452-21)

The Color of Peace

P44–45. I love to paint with focus. And the nice thing about painting with a camera is that it takes less than a second, as it did here at Tahkenitch on the Oregon coast. (#605-11)

P45, right. After surviving cancer, back at Wilbur Hot Springs to greet another remarkable spring. (#106-5)

P46. One persistent leaf, hanging on. Fall always feels sadder than spring, to me, but is no less beautiful. (#430-6)

P47. Several people have told me what they see in this Japanese garden scene. If I told you what, you'd be less likely to see your own magic. (#372-17)

P48. One of nature's elegantly simple compositions at Oregon's Rough and Ready Creek—another special, threatened place. (#574-22)

P48–49. This is Lurch. Or is it Dot? I forget, frankly. He, or she, never knew either. (#318-24)

P49, right. Our bedroom window, from the backyard. Green the color of peace even, or especially, there. (#559.3-3)

Perseverance

P50–51. This sprout from the Wilbur Hot Springs mud gave me much inspiration when I was diagnosed with cancer and had to leave to do similarly hard growth. (#5-10)

P51. Part way up the face of Castle Crags, a few trees don't know that their natural tenacity is spectacular. Many people's strength is the same. (#233-24)

Living the Spirit

Home

P55. I was bending down to look at something else when I saw these eggs. I photograph what I see, but rarely what I look for. (#226-24e)

P56. So well blended, I almost stepped on him. Sometimes camouflage backfires. (#446-13)

P57. Our dining room and back yard, reflected in the glass over a beautiful painting by my mother, Shirley. (#479-27)

P58–59. Sky at dawn by Crescent City, waiting for the Aleutian geese to fly. (#457-10)

P59, upper right. Zig-zag leaves on the back side of Mt. Ashland. (#452-23)

P59, lower right. A remarkable driftwood sculpture by an artist named the sea, near that imagined Oregon/California line. (#456-8)

P60. I was just trying to use up film in my apartment. Sometimes the best images come about when no obvious subject presents itself. (#187-26)

Surroundings

P61. My own bootprint on the ice of Hyatt Lake. Another resonant whim. (#165-7)

P62, left. One grass blade at a bird refuge in California's Central Valley that almost no one notices as they race by on Interstate 5, a few hundred yards away. (#448-22)

P62, right. A flower reaching out to greet all sidewalk passers-by. (#424-10)

P63. Growing despite obstacles in Mendocino. This was one of the first photos I took after September 11. Consciously, I didn't know why. (#530-8)

P64. I went to this garden to photograph someone's paintings. This worked out better. (#178-4)

Religion

P65. I love old churches. I just don't find my own religion there. This one's near Taos, New Mexico. (#343-26)

P66, left. Ashland's foremost greeter used to nip tourists enthusiastically—natural beauty isn't always non-violence. (#108-9)

P66–67. Mt. Shasta is powerful enough to make its own weather. (#271-20)

Sex and Intimacy

P68. The Pu'ako petroglyphs in Hawaii. Sex is no new discovery. (#86-16)

P69. Wilbur Hot Springs, after I beat cancer. I was blooming too. (#225-18)

P70. The perfect heart-shaped leaf, floating in stillness on Ashland Creek. (#542-24)

P70–71. A generation of lovers have carved this seaside Mendocino bench. (#531-20)

P72. The initials were carved in this eucalyptus so long ago that they grew back into unreadability. Only the heart remains visible. (#543-6)

Clothes

P73. A beautiful place to live, in a Mendocino garden. (#530-19)

P74. One of my favorite shirts. Jane brought it to me from Bali. (#569-24)

Family and Community

P75. Tadpole clan at Deadfall Lakes in California, near Mt. Eddy. (#521-19)

P76. This particular thistle was drawing all the bumblebees, while plenty of other nice ones were ignored nearby. Same thing often happens between men and women. (#125-18)

P76–77. As a kid, I made jigsaw puzzles out of scenes like this, but I wasn't sure the real scenes existed. In southern Oregon, they still do, but developers are chewing up land faster than sheep. (#285.5-x)

P77. Geese and grebes at Lower Klamath Wildlife Refuge. As noisy as any other traffic jam, but much less frustrating. (#275-8)

P78. Another extended family gathering in the Lower Klamath Wildlife Refuge—one of the loudest parties I've ever been to. (#168-20)

Exercise

P79. Shorebirds doing wind sprints on an Oregon beach. (#550-14)

P80, left. This butterfly is also the essence of grace, in motion or stillness, on Michigan's Mackinac Island. (#469-14)

P80, bottom. Victoria showing the essence of athletic grace on Ashland's Hitt Road. (not available)

P80–81. Even a slow-motion Mendocino slug is graceful. (#535-20)

P81, right. Not my usual bicycle. These old classics served us well on the minimal hills of Mackinac Island. (#470-10)

P82. A meditative running trance on Ten Mile Beach, several miles south of the above slug. (#452-5)

Stillness

P83. In heaven with Jane, otherwise known as Micmac Lake in Tettegouche State Park, Minnesota. A perfect dawn, a canoe and a lake to ourselves. (#369-1)

P84. Another sunset at Bandon on the Oregon coast, with seagulls and stillness for our companions. (#546-3)

P85. On the peak of Mt. Joseph in the Wallowa Mountains, just west of the Idaho border. Hoping I brought extra lunch, I'm sure. (#516-18)

P86. Mt. Eddy and one of Deadfall Lakes, near Shasta. Colors are amazing where the earth is pure. (#357.5-20)

Balance

P87. Sometimes artistry is a mistake. I like this one better than the photo taken at the intended speed. (#223-10)

P88. I haven't been to Mars, yet, but I've been to the Painted Hills of the John Day Fossil Beds in central Oregon, which is the next best thing. (#506-7)

P89. Stillness and wind in the same Mackinac flowers. (#468-22, 468-21)

P90, upper. Silver river splits grey sand as it joins the sea in Bandon. (#550-23)

P90, lower. The sea at Bandon really looks like this. It's merely a matter of perspective. (#549-6)

Work

P91. Deer are one of several species profiting from human overabundance, in the short term; and from the perception of them as "cute." (#601-37)

P92. Shortly after I photographed this metalwork at Oak Street Tank and Steel in Ashland, the building was converted to an upscale artisans' mall. (#432-10)

P93. Mercury mine near Wilbur Hot Springs, abandoned a century ago. At the nearby homestead, daffodils and roses still bloom without a gardener. (#272-36e)

Education

P94, left. An abandoned one-room schoolhouse in the Colestin Valley in northern California. If education budgets keep shrinking, it may need to be pressed back into service. (#189-5)

P94, right. Tiles painted by children at Ashland's Helman School. (#425-18)

Money

P95. No matter the minted slogan, money is not true liberty. (#571-20)

Ownership

P96–97. Bear Valley, California, where fences, flowers and cows coexist. Does it serve the earth? (#278-25)

P97. Jacksonville, Oregon. The center of a flower speaks for itself. (#394.5-4)

P98. The local duck pond, fall colors and time off. Aaahh. (#540-8)

P99. A Lost Coast trail by the sea. The day's wild wind isn't apparent. (#357-14)

Food

P100. A Hawaiian feast at my feet, on the big island. (#400-18)

P100–101. I'll bet most supermarket consumers don't know bananas grow upwards. These were right next to the pineapple. (#400-17)

Health

P102, upper. Mendocino garden. The background is the subject; the twig just is. (#448-24)

P102, lower. Michigan summer color. (#469-16)

P102–103. Waipio Valley in Hawaii: beautiful, rugged, province of locals. (#409-3)

P103, right. The center of the world may be the center of a flower. (#394.6-14)

P104. No Christmas tree ornaments will ever better these botanicals. (#535-3)

P104–105. Colors like these keep me from carrying black and white film. (#450-16)

P105, right. A crab giving back to the soil, after completing its life in the ocean near Tahkenitch. (#606-1)

Music

P106. Electricity channeled into beauty. (not available)

Conflict

P108. The mud of Kauai isn't as famous as the other scenery, but it's just as impressive. This print was on the cliffs at Mahauleeu. (#412-1)

P109, left. Fort Mackinac in Michigan, site of battles and shelter since 1790. It all turned to tourism eventually. (#610-11)

P109, right. No one ever buys greeting cards of a flower if it has a fly on it: I learned this the hard way. (#290-12)

P110. A rough-legged hawk flaunts its protected status in the Lower Klamath Wildlife Refuge. (#440-24)

P110–111. Fort Mackinac cannon dating back to the British/American war of 1812. (#610-7)

P112, left. Yellowman was a feral cat who wouldn't let anyone near him until he became diseased and had to be trapped. After healing, he became a loving house cat. He finally trusted the alliance. (#321-26)

P112–113. The moon, Mt. McLaughlin and Upper Table Rock. Not as distant or separate as they seem. (#437-2)

P113, right. Bald is beautiful, as middle aged men used to say. (#508-5)

P114. Another wordless tale of perseverance— this one told in the language of Oregon snow. (#254-10)

Sleep and Dreams

P115. The Crescent City ocean at sunset. Most just drive through on the freeway without venturing over to the sea. (#459-18)

P116. Gold Beach, Oregon, near sunset. I met someone I loved that day. (#240-8)

P116–117. In every Bandon sea foam bubble, a reflection of self. (#564.25)

P117. These days, you'd have to get up before dawn to be this alone on Hawaii's Hapuna Beach. I was lucky back then. (#84-24a)

P118. My friend, who lived on this land without amenities, called it the Third World. How little sense the numbering of worlds makes. (#207-1)

P118–119. Gold Beach and the infinite universe beyond it. The stars are all buried there, behind the blue. (#242-10)

P119, right. Cemeteries are peaceful places, full of sadness but also full of rest, silence and the loving remembrance of souls. (#238-10)

P120. Photographically, the book ends as it began: with a view from my own living space. A day which begins like this is special. It's all worth getting out of bed for. (#538-2)

AUTHOR PHOTO BY JANE BROCKMAN

Eric Alan began to find his connection to nature at a young age, in the wilderness of suburbia. His explicit recognition of it as a cathedral and spiritual path came later, while pursuing the integration of writing, photography and music. His photography has been featured in galleries in Oregon and California, and has been published and distributed in many other places. As a writer, he's been professionally active as a lyricist, journalist, novelist and editor. He also authored a hand-made book integrating photographic and verbal visions at Wilbur Hot Springs in northern California, while resident artist there. His professional credits also include twenty years in the music business in varied capacities. Currently living in Ashland, Oregon, he's regionally known for his work with Jefferson Public Radio, as music director, on-air DJ, and editor of the magazine *The Jefferson Monthly*. He can be reached via www.wildgrace.org, at eric@wildgrace.org.